The Campus History Series

KEAN UNIVERSITY

The Campus History Series

KEAN UNIVERSITY

ERIN ALGHANDOOR, FRANK J. ESPOSITO,
ELIZABETH HYDE, AND JONATHAN MERCANTINI

ARCADIA
PUBLISHING

Copyright © 2017 by Erin Alghandoor, Frank J. Esposito, Elizabeth Hyde, and Jonathan Mercantini
ISBN 978-1-4671-2583-3

Published by Arcadia Publishing
Charleston, South Carolina

Printed in the United States of America

Library of Congress Control Number: 2017932976

For all general information, please contact Arcadia Publishing:
Telephone 843-853-2070
Fax 843-853-0044
E-mail sales@arcadiapublishing.com
For customer service and orders:
Toll-Free 1-888-313-2665

Visit us on the Internet at www.arcadiapublishing.com

To the Kean University community—past, present, and future.

CONTENTS

ACKNOWLEDGMENTS

A book with four authors would seem to have many pitfalls, yet the entire process was extremely smooth.

This book would not have been possible without the help and support of many people in the Kean community. Pres. Dawood Farahi, Provost Jeffrey Toney, and Dean of the College of Liberal Arts Suzanne Bousquet provided essential support to all of us, enabling us to undertake this project. We are grateful for the backing of the Kean University Foundation and of the Kean Office of Alumni Affairs under the direction of Stella Maher and president of the Kean Alumni Association Edward Esposito.

Monifa Clunie in the Office of the President provided access to images from the office that we are proud to feature here. University Relations opened up their archives so that we could locate and include many pictures. Ricardo Fonseca helped to scan many of the images that we located in those archives as well as those in the university's special collections. Joseph Moran, Erin Lee, Kevin Bartolotti, and Ann Lyle also helped us find and scan images.

All of us are fortunate to work with colleagues in Kean's outstanding Department of History who create an environment in which excellence in scholarship and teaching are valued.

The book benefitted from the hard work of several of our students who contributed to this project: Kristina Cibikova, Charles Caramico, Jessica DiFranco, Laura Hurley, Michelle Thompson, and Leanne Manna.

We are thankful for all the wonderful photographs from the John Kean Collection at Liberty Hall Museum in chapter eight. William Schroh, Rachael Goldberg, and Lacey Bongard of Liberty Hall Museum were helpful checking our facts.

Maria Perez, Suzanne M. Kupiec, and Patrick Ippolito answered email queries about the history of Kean.

Kimbery DeRitter from the Athletics and Recreation Department provided the recent sports team photographs.

Stacia Bannerman welcomed this project to Arcadia Publishing and helped see it through to completion.

We all owe a deep thanks to our families who have supported us in the completion of this project, just as they have encouraged and strengthened us throughout our careers. In particular, we are proud to set high standards and demonstrate the rewards of hard work to our children.

Unless otherwise indicated, all photographs are courtesy of the Kean University Archives and Special Collections and Office of University Relations.

INTRODUCTION

Kean University's mission statement states that Kean "prepares students to think critically, creatively and globally; to adapt to changing social, economic, and technological environments; and to serve as active and contributing members of their communities." The story of Kean, as told in this photographic history, is the story of 162 years of working to meet that mission. It is the story of students preparing to become educators to serve a growing America. It is the story of its students becoming engaged global citizens and of a student body changing with America. For the history of Kean University is in many ways the history of public and higher education in the United States—the expansion of educational opportunities to broader segments of the population and the evolution of educational offerings to meet changing pedagogical, technological, and professional needs.

The photographs in this volume document the evolution of Kean, and of public institutions of higher education like it, from their origins as normal schools for teacher training, to the modern university offering a full range of liberal arts and professional programs. They simultaneously reveal social and cultural change in America, as the school grew from an institution intended to train young women for careers in teaching to a university serving a diverse population reflecting the changing demographics of America.

The history of Kean University, now located on a 180-acre-plus campus in Union, New Jersey, began in Newark in 1855. As Newark grew, so did its need for teachers, and the Newark Normal School was established. The school had its home within Newark High School until 1879, when it moved to the Market Street School. Growing demand finally led to the construction of the first free-standing Newark Normal School in 1913 on Fourth and Belleville (now Broadway) Avenues, at which time New Jersey assumed control of the school. The new school building could boast of modern classrooms, an auditorium, and a gymnasium. In 1937, the school was renamed the New Jersey State Teachers College at Newark, but in common parlance it was referred to as Newark State Teachers College (NSTC). While declining enrollments during the Depression led the state to threaten its closure, students rallied successfully to keep the school open.

With the return of World War II veterans, NSTC enrollment swelled beyond the capacity of the building. A search began for space, and NSTC leadership determined it would be necessary to look outside of Newark. The Green Lane Farm, part of the Kean family estate in Union Township, offered sufficient acreage for years of growth ahead, and the Kean family eventually agreed to sell the property to New Jersey to create a new home for NSTC. The new campus opened in 1958, at which time the school was renamed Newark State College,

the name it would bear until 1973, when it became Kean College. The growth of Kean's curriculum to include postgraduate degrees led to its receiving university status: it became Kean University in 1997.

In the 21st century, the school that had grown from serving the city of Newark into a regional university began to alter its identity from a regional and state institution to an international one. Within New Jersey, Kean established campuses in Ocean County and the New Jersey Highlands. But Kean has also expanded globally: its most ambitious venture to date came to fruition with the 2012 opening of a branch campus in Wenzhou, China.

The dramatic expansion of the physical campus of Kean is matched only by growth and evolution of its student population. As a teacher training school, the first students of Newark Normal School were single young women who sought teaching positions within the city of Newark. Teaching was one of few occupations open to women in the 19th and early 20th centuries, and the student population would remain predominantly female until after World War II. In the 1920s, the school established a program in the industrial arts that contributed to the growth in male enrollment. That number would decline dramatically during World War II, when male students entered military service: only nine men were enrolled in 1943. The male student population rebounded after the war and with the passage of the GI Bill. Today the university, like most institutions of higher education in the 21st century, has slightly more female than male students. Through most of its history, Kean has been a commuter school, and it therefore served a local and regional population. As that population has grown in diversity, so has the student population, demonstrating continuity in its stated mission to serve "socially, linguistically, and culturally diverse" students. While early photographs reflect the small numbers of persons of color, the student body of Kean University today has earned national recognition for its diversity. And just as the Newark Normal School and NSTC were populated by daughters and sons of recent immigrants to the United States, Kean University proudly continues to educate students whose families are new to the country and new to higher education.

The photographs also document a rich campus culture. From its beginnings, the teacher's college embraced progressive teaching philosophies and practices. Model classrooms and teaching practicums became part of the curriculum early in the institution's history, and Kean has led the way in incorporating the latest technology in all its educational programs. Among its sister institutions in New Jersey, Kean still produces the largest number of future teachers. From its beginning, these future teachers built a vibrant campus united around the arts, from the performance of festivals for the children they taught to the staging of original theatrical and musical productions. Once established in Union, Kean played host to a long line of important performers. In the heavily political 1960s and 1970s, the campus music scene included concerts by the Highwaymen, Count Basie, and Jerry Garcia of the Grateful Dead; even a young Bruce Springsteen played on campus several times in the 1970s. And despite its origins as a local institution, the students have always engaged with global events around them. In World Wars I and II, Newark Normal School and NSTC students found many ways to support the war effort, either through volunteering and fundraising or through military service. During the 1960s, the college did not shy away from the complicated politics of the day. The Townsend Lecture Series brought important thinkers and activists such as Eleanor Roosevelt and Martin Luther King Jr. to the campus. In 1993, Khalid Abdul Muhammad, at the time a leader in the Nation of Islam, delivered a controversial speech that sparked a national conversation about race, anti-Semitism, and free speech.

In the modern era, Kean University continues to embrace the global community, growing its early tradition of international student travel to the creation of the global Human Rights Institute and the exchange of students and faculty between Kean in Union and Kean in Wenzhou, China. While building for the future in China, Kean continues to grow its historical roots. In 2007, Kean acquired Liberty Hall, the historic estate of William Livingston and the Kean family. The addition of the Liberty Hall Museum and archives ensures that a sense of history and innovative teaching will continue to shape the future of Kean University.

One

TO TEACH THE CHILDREN
OF NEWARK

From 1855 to 1910, the city of Newark, New Jersey, increased in population from 53,000 to 343,500. In order to meet the growing need for teachers in the city's school system, Newark Normal School was founded by the Newark Board of Education in 1855. From its founding until 1913, when control of the school was assumed by the state, Newark Normal School prepared hundreds of teachers to educate the rapidly growing city's youth population. Interestingly, there is little surviving documentary evidence about the school during these early years.

The ethnic composition of the students also changed during these early decades. When the school opened, the future teachers were overwhelmingly Protestant. By the time the state assumed control of the school in 1913, more than 30 percent of the student body was drawn from the immigrant and Catholic communities of the city.

Despite the often-cramped conditions, the result of the normal school not having its own building until 1913, a succession of leaders created a warm and positive learning environment that would remain a hallmark of the school.

This era also saw the growing professionalization of teacher training. Initially, classes met on Saturday mornings. By 1913, students completed a two-year curriculum that balanced subject knowledge with an emphasis on moral character and classroom discipline. Future teachers received instruction in traditional academic subjects such as history, English, biology, chemistry, and physical education and had the opportunity to observe model teachers before completing their training as student teachers in schools throughout Newark.

In these first decades of what would become Kean University, the school and its teachers, students, and curriculum were in many ways quite different from the university today. A comprehensive curriculum, graduate programs, and a student body in excess of 14,000 all lay in the future. However, the growing diversity, expansion of academic rigor, and new buildings that mark this period remain priorities in the present day.

9

| Normal School | IV A Normal School for the improvement and education of Teachers shall be Established in the High School Building. The Studies prescribed by the Board of Education in the Public Schools and the best methods of tuition and Government will be taught by the instructors in charge of the Normal Schools. |
| When to be held | The School will be held on Saturday of Each Week during the regular terms of the Public Schools and shall Commence at 9 o'clock A.M. and Close at 1 o'clock P.M. |

Newark Normal School was founded in 1855 and opened on April 14 of that year in the city's high school. The school met on Saturdays from 9:00 a.m. to 1:00 p.m. Newark Normal School was typical of 19th-century American education training. Professional courses were to be emphasized, but in reality, subject matter training became the school's focus. There were no courses in teaching methods. The cost for running the school was $700 per year.

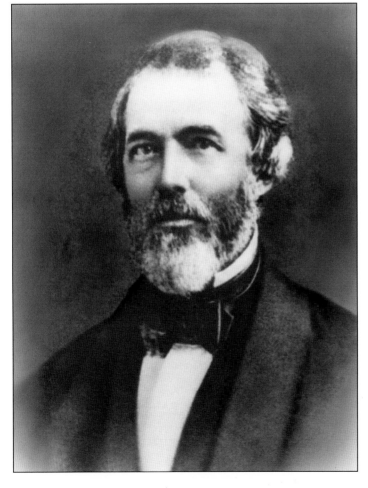

Considered the father of Newark's public school system, Stephen Congar served as superintendent of Newark schools from 1853 to 1859. In 1855, Newark's school-aged population represented 40 percent of the entire state of New Jersey's. To meet the rapidly growing need for teachers, Congar strongly advocated for the normal school.

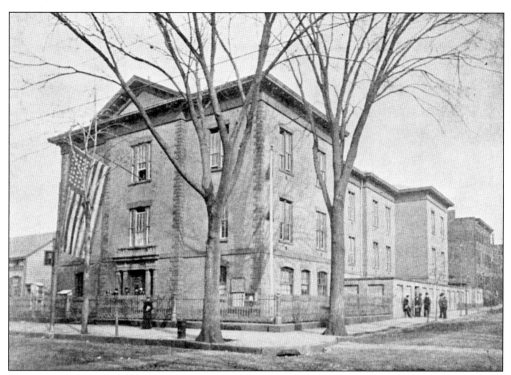

Located at Washington and Linden Streets, Newark High School served as the first home of Newark Normal School from January 7, 1855, until the spring of 1878. Newark Normal moved to the Market Street School for the next two decades, but that building was badly outdated, and the teacher trainees returned to the former high school until 1913. Normal school classes took place on Saturday mornings. The space was not ideal. It included 19 classrooms but lacked a communal hallway, forcing students to walk through multiple rooms to get from one side of the building to the other.

In keeping with the labor standards of the time, in which a 10-hour workday was the norm, training in the normal school was rigorous. The school's first graduating class in 1859 included seven men and ten women. This was the largest number of men ever to graduate from the normal school. The advent of the Civil War and the economic and business opportunities in Newark in the late 19th century meant that 561 women and only 35 men graduated from the Saturday normal school.

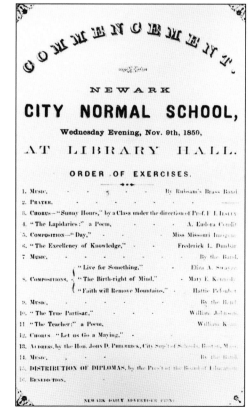

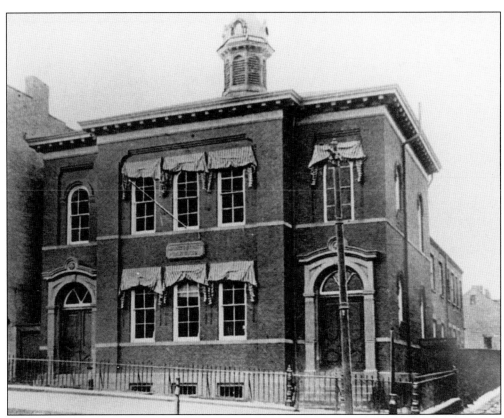

The Market Street School, one of the oldest in the city, was used as the training school for normal school students from 1878 to 1899. The building was small and crowded, with poor ventilation and sanitary facilities. The students were led by the first full-time principal in the school's history, Jane Elizabeth Johnson, a Vassar-educated teacher who was also the school's only full-time faculty member. When the normal school curriculum was doubled in 1879, an additional room was occupied in the Market Street School. Despite this growth, the board of education was unwilling to bear the expense of a separate building. Here students, all of them women at this time, prepared for teaching careers in elementary schools.

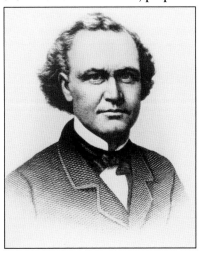

Isaiah Peckham served as the first principal of both Newark High School and Newark Normal School. At the time, "principal" meant "principal teacher," and Peckham ably fulfilled that role. He also strongly advocated for strengthening public education in the state and served as a founder and first vice president of the New Jersey State Teachers Association.

Jane Elizabeth Johnson served as the first full-time principal of the normal school beginning in 1879. Johnson had previously taught at Vassar and brought excellence and expertise as a classroom teacher to the normal school faculty. According to one writer, Johnson made such a strong, positive impression that children of her former students still talked about her a century later.

Joseph Clark taught for more than 30 years in the Newark schools before becoming principal of the normal school in 1894 at the age of 70 for a five-year term. Described as kindly and patient, he may have lacked the energy that the board of education believed a principal required. Clark protested his ouster but was replaced after commencement in 1899.

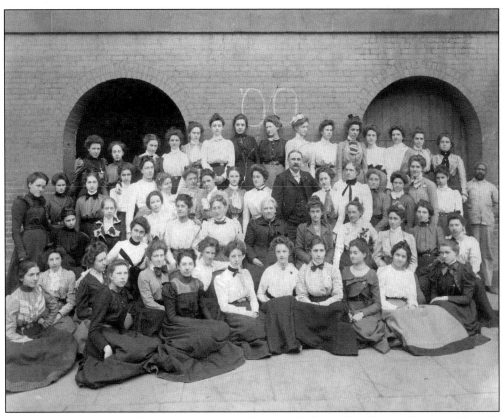

This picture of the class of 1900 demonstrates the overwhelming female enrollment at Newark Normal School. Normal school candidates were required to have a high school diploma. Tuition was free. The school board estimated the cost per pupil at $64.33. Of the 42 graduates in the class of 1900, only 19 completed 10 or more years teaching in the Newark school system. Some presumably went to teach in other districts, while others, following the custom of the time, stopped working outside the home after marriage and having children.

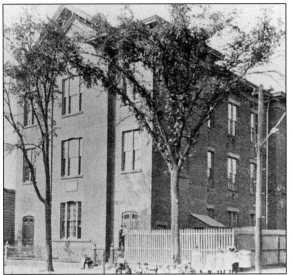

The Webster Street School, located on Webster Street at the corner of Crane Street, served as the model training school for Newark Normal students from 1901 to 1921. Seniors in their first semester reported to a single classroom and a mentor-teacher in their fall semester. For their spring semester, they were assigned to a school elsewhere in Newark to complete their degree. According to students, Webster Street School was used for training because "if you could teach there, you could teach anywhere." Practicum requirements at this school ceased in 1921, when students were allowed to choose schools closer to home.

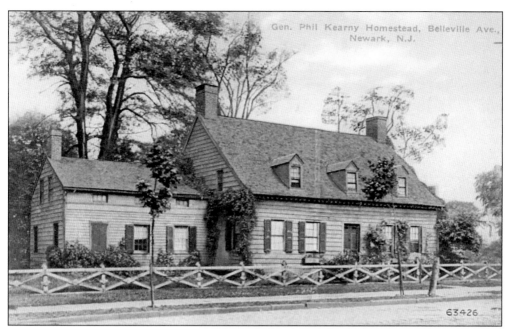

63426

In 1909, the Newark Board of Education purchased the Kearny homestead in the Woodlawn neighborhood in North Newark. It was named for New Jersey Civil War hero Philip Kearny, who grew up on the property. The city issued $300,000 in bonds, most of which was earmarked for the purchase and construction of the new school building. A plaque noting Kearny's childhood homestead and honoring his military career was created by the Newark Board of Education in 1912.

This statue of Philip Kearny was located in Military Park in Newark. The park was part of the original plan for the city. Initially used as a training ground for soldiers, the space was converted into a town commons in the 19th century. The statue was unveiled in 1879. It features General Kearny, who lost his arm in the Mexican-American War.

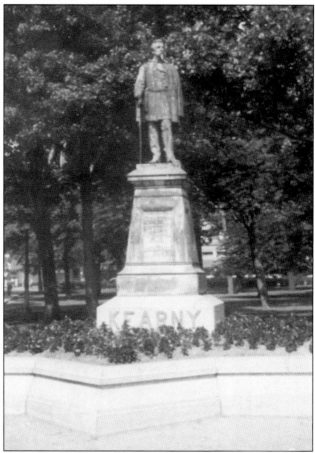

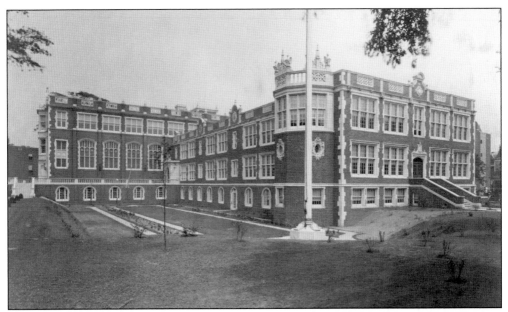

Ernest F. Guilbert was the chief architect of the new school building, situated on Belleville (now Broadway) and Fourth Avenues. His Collegiate Gothic design, shown here, emphasized tall and wide windows to provide ample light and air. The exterior featured an octagonal tower, tracery parapets and pinnacles, sculptured relief, ornamental carvings, and gargoyles. The building included a new gymnasium, science laboratories, a library, and a reception room. A manual training shop and a sewing room underscored new trends in public education in the early 20th century. The ravine that cut through the Kearny property became a sunken garden where many a future graduation would be held.

This view of the normal school building is from Belleville Avenue. The new building would provide an excellent home for the school for many years. By the 1950s, however, the growth of the student body and the addition of new programs once again led the school to look for a new location and more space.

The school's motto was written by John Cotton Dana, the Newark librarian. Normal students frequently walked or took the trolley to take advantage of the Newark Library, as their library contained mostly textbooks. Asked to research a motto for the school, he could find none that he considered fitting and instead offered his own, which was set above the front door. Below the inscription are four sculpted faces, which represented the four races of man. The motto, and quotations from Huxley and Emerson that were also inscribed, served as conversation starters for students and faculty.

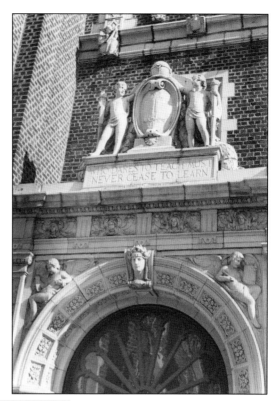

Pictured is one of eight grotesques by G. Grandelis placed on the new building's cornices. These sculptures symbolized music, botany, chemistry, thought, history, writing, mathematics, and study. They are still visible today from the upper windows of the building. After the institution relocated to Union in 1958, the building continued to be used for educational purposes, first as the Center for Occupational Educational Experimentation and Demonstration, and currently as Technology High School.

17

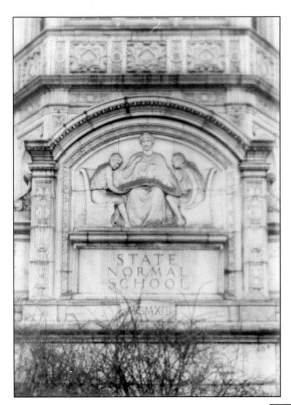

This relief statute features a teacher and two students, male and female, dated 1912. It was placed along the sidewalk of Belleville Avenue and is still standing today. Here is the only place the phrase "Normal School" is seen on the property. Though the concept of the normal school was pioneered in Prussia, the English translation of the French phrase "école normale" was the one adopted in the United States. Normal schools were designed to teach high school graduates how to be elementary school teachers.

Like so much of the building's design, this gargoyle atop one of the corners of the normal school edifice shows the attention to detail that went into the design of the new building. The building, together with the state taking control of the school, marked a major transition in the school's history. Now it would provide teachers for schools not only in Newark but throughout the area.

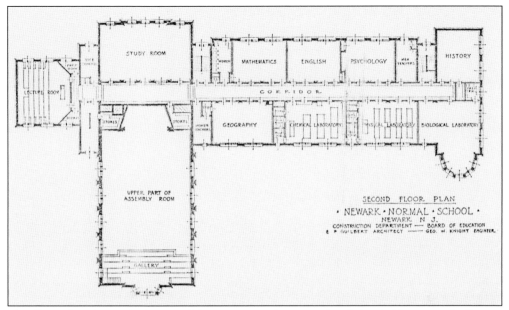

This floorplan shows the layout of classrooms in the new school. One of the main challenges the architects faced was insulating the school against the noise of traffic and streetcars outside the building. Guilbert's solution was to place the classrooms in the back of the building, as far from the street as possible. Note the emphasis on traditional academic subjects and the creation of larger spaces to meet the needs of the growing population.

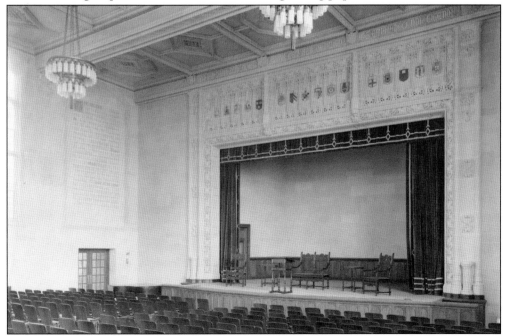

The auditorium in the new building could accommodate more than 700 people. It was described as having outstanding acoustics and visual charm. With the new auditorium, the school no longer had to hold events, including commencement, off campus. Similarly, the new gymnasium eliminated the need for students to use recreational facilities at the YMCA.

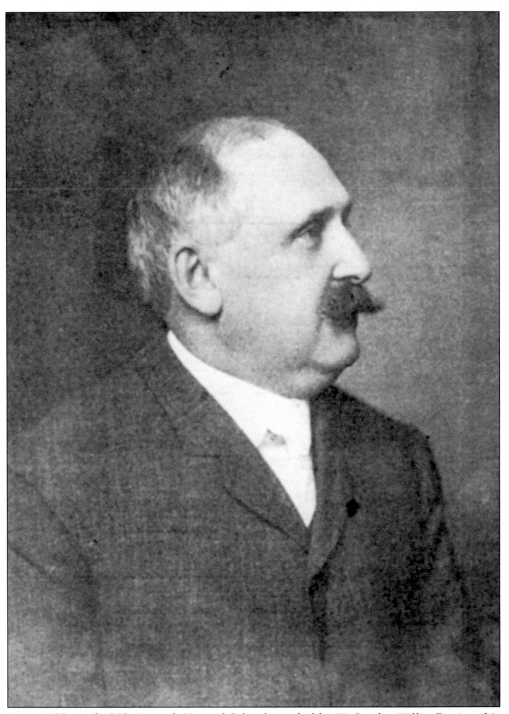

From 1899 until 1928, Newark Normal School was led by W. Spader Willis. During this period, enrollment grew rapidly, exceeding 1,000 students by the 1920s. Newark Normal was the largest teacher preparation school in the state and one of the largest in the country. Willis's greatest achievement was preserving the human dimension of the school as the student body expanded.

Two

AN INSTITUTION GROWS
IN NEWARK

A golden age at the normal school began with the construction of the state-of-the-art building on Fourth and Belleville (now Broadway) Avenues and the assumption of stewardship of the school by the state. At the start, students attended classes for two years and earned a certificate in general education, kindergarten-primary, or manual training. All programs were open to men and women with the exception of manual training and industrial arts, added in 1924, which were limited to men. Fine arts was added in 1932.

US senator Joseph S. Frelinghuysen, the former president of the New Jersey Board of Education (1915–1919), described the new campus as the "Sunshine School." Principal William Spader Willis was delighted with the phrase, and it stuck for quite some time. Most of the students and faculty exuded a joyful presence, which is evident in the pictures and writings from this time. The student papers and yearbooks show the varied interests of the student body.

When World War I broke out, many men and women took initiatives to help at home and abroad, which were featured in the *War Bulletin*, printed in 1920. The school also donated money for the rebuilding of the library at the University of Louvaine in Belgium, where the banners of Newark Normal and 60 other schools were hung in the large reading room.

By 1934, college degrees replaced teaching certificates at the school; the program of study could be completed in three to four years. Extension courses were offered to active teachers in the evenings and on Saturday mornings. In 1937, the institution was renamed the New Jersey State Teachers College at Newark. However, most people simply referred to it as Newark State Teachers College. Given the successful growth of the campus, it came as a surprise in early 1939 when the New Jersey legislature opted to close the school, arguing that there were too many teaching schools in the state. Over 30,000 signatures were gathered on a petition, and the decision was overturned. The camaraderie of the school and greater community was strong, which would prove to be important with US involvement in World War II a few short years away.

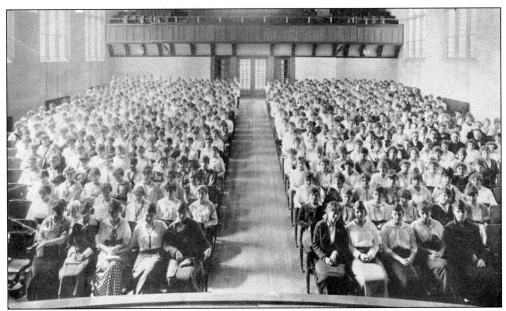

The assembly room in the new school building could seat more than 700. The previous building did not have a room that could accommodate the entire student body, so assembly programs were new. Students were assigned seats at the beginning of the year based on their vocal types for group singing. The space also gave students an opportunity to practice platform speaking.

Early course catalogs included a class called Nature Study, which placed an emphasis upon the living organism and included a biological laboratory equipped with living plants and animals and the various devices for housing them. The first science club was started in 1929. In the 1940s, classes in biology, chemistry, physics, geology, and astronomy were added to the curriculum, as were courses in teaching science to children.

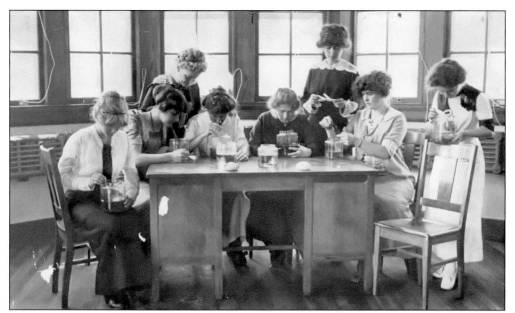

An applied science class was designed to give knowledge of facts related to everyday life, like weather, and used the school building as the basis for many practical lessons, such as heating and electricity. Students were encouraged to recognize and use the many opportunities in a child's immediate environment for developing scientific method and knowledge at their level. In the 1950s, a student could specifically prepare for certification as a science teacher.

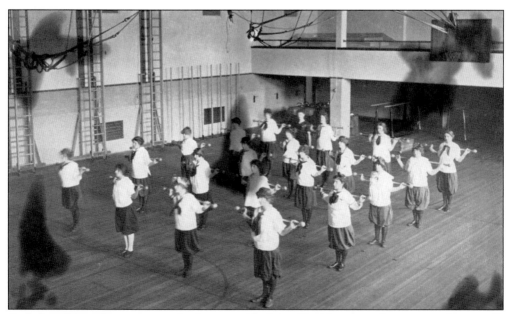

Each female student was required to provide herself with a complete gymnasium outfit consisting of dark blue bloomers, a blouse, and gymnasium shoes. This outfit could be secured from the physical training director for about $4. Interestingly, although the school included male students, there is no note about what the men were required to wear for physical education.

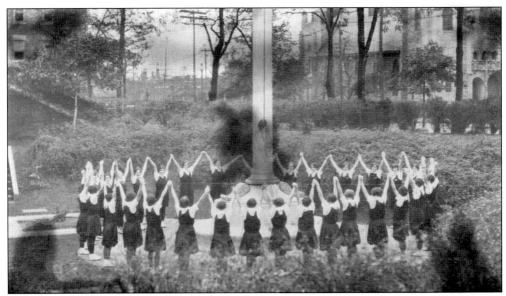

Physical education prepared students for classroom work. According to the 1918–1919 course catalog, it also gave "courage to the timid, energy to the sluggish, grace to the awkward, the recognition of the place of play in the child's life and the sincere desire to make the mind a worthy inhabitant of a well-built and cared-for house." The previous image and this one were joined together on a page of the yearbook and described as "a transition from formal exercise to freer expression."

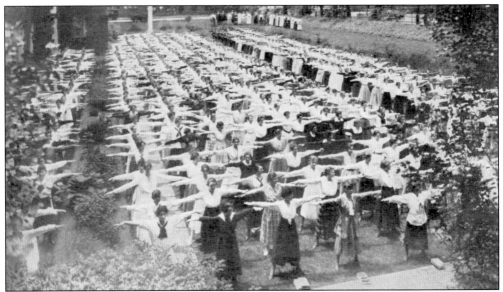

In the 1938 yearbook, Bertha R. Kain wrote, "students, nearly a thousand strong, would be marched out into the sunken garden where they would be formed into military formation and would salute the flag flying from the pole. . . . Then Mr. D'Angola, armed with amplifier, would shout directions for formal gymnastics and all would comply with military precision, the spectacle being attractive enough to stop trolleys and draw crowds along the fences who gazed and applauded."

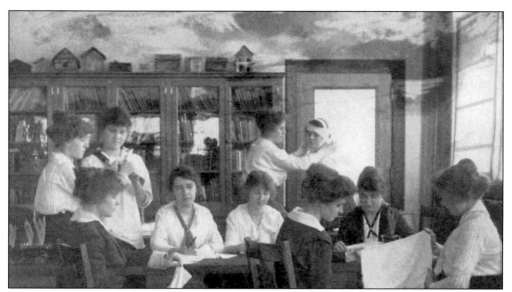

The 1918–1919 course catalog states: "It is rare to find a teacher in the ordinary grade school who is a graduate of First Aid. The Newark State Normal School is attempting to equip the young teacher in this line. First aid in accidents, emergency measures and practical lessons in bandaging are covered by this course." Lucky was the class whose teacher was well prepared for mishaps in the classroom or playground.

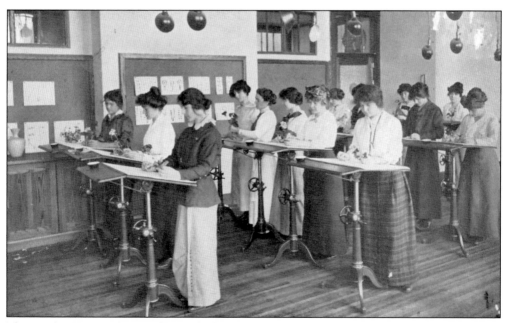

The 1918–1919 course catalog included courses covering the teaching of art principles, handicraft and home economics, the appreciation of beauty, and training in "chalk handling and blackboard sketching." In 1932, fine arts was added to the curriculum and included courses in design, painting, sculpture, industrial arts and crafts, interior design, leatherworking, bookbinding, and more. The fine arts program proved to be an enormous success, and demand for additional classes and instruction increased after the first year.

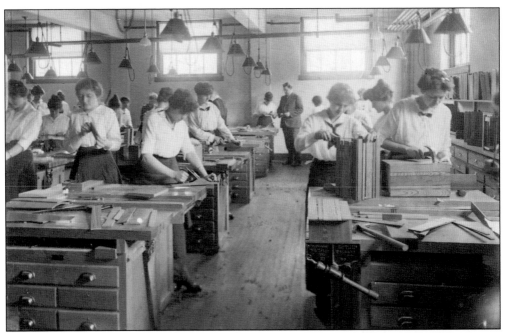

Manual training was first introduced in 1902. Prior to 1922, all the female students received training in the use of a hammer, chisel, and saw. In 1924, the curriculum for manual arts and industrial arts was established. This image highlights the gender divide in the new program.

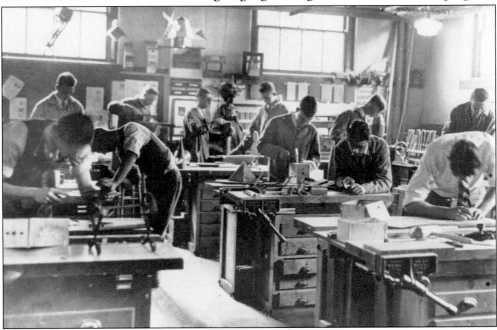

The New Jersey Board of Education decided to establish a two-year special course at the State Normal School at Newark to prepare men to direct manual training in elementary and junior high schools. In 1922, twenty-four men were admitted to the program, which included instruction on wood- and metalworking, industrial drawing, and electricity. The massive demand for teachers in these areas made it the most successful program in the school.

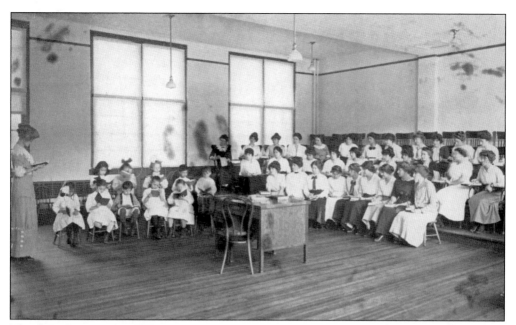

The demonstration room was located on the first floor and provided a tiered seating area for normal school students to observe an experienced teacher interacting with children. While informative, it lacked the elements of fun that are visible in the kindergarten class, seen in the following picture.

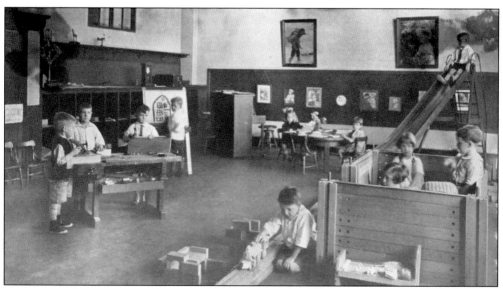

In 1923, the school established an actual kindergarten class on campus. It allowed students to observe and train with teachers and children. In addition to the general entrance requirements, students who wanted to take the kindergarten course were required to have a good singing voice and the ability to read and play instrumental music. The kindergarten demonstration school also provided health, mental hygiene, and developmental advice to the families of children enrolled.

Strengthening the creative impulses of children was an emphasis of the progressive education movement. Sybril Browne, a visionary faculty member, insisted on art education for all students while decrying mediocrity. Many of her former students, such as Clem Tetkowski, would go on to teach art in colleges and universities throughout the region.

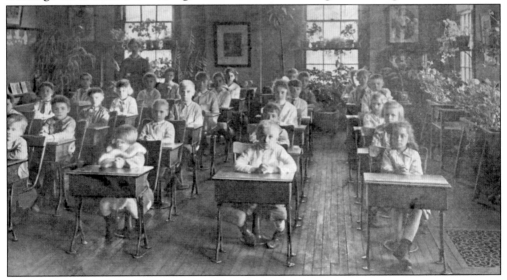

According to the 1918–1919 course catalog, prospective teachers could observe students at the Normal School. While many students took part in student teaching near the campus, the Normal School had four rural school practice centers in Northern New Jersey. This practice in instruction and classroom management was similar to the current student teacher training model.

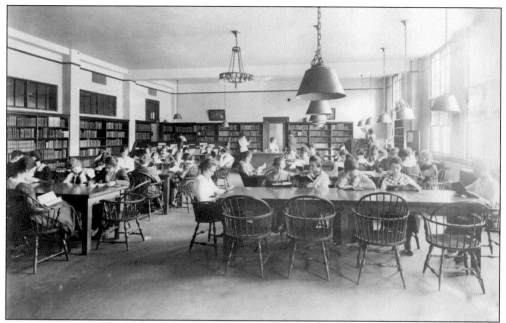

Space and books were always at a premium in the normal school library, and a series of principals struggled to enlarge and improve the collection. The jewel of the library was a collection of children's literature unrivaled in the state. For many other books, however, students "jogged back and forth to the Newark library," according to college historian Donald R. Raichle. Students joked that this embodied the Greek ideal of training both the mind and the body.

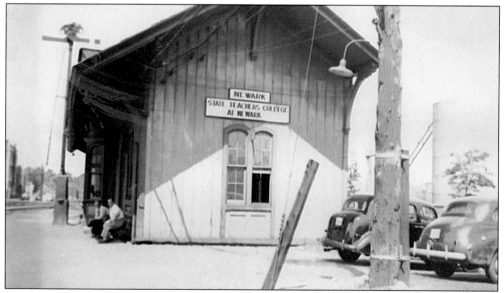

The Newark station of the Erie Railroad Company at Fourth Avenue was a few short blocks from Belleville (now Broadway) and Fourth Avenues. This photograph shows the station, labeled "Newark, State Teachers College at Newark," the school's new name in 1937. Despite the official name of the institution, most of the administration and students referred to it as Newark State Teachers College.

Bertha R. Kain served as the interim principal after the retirement of Principal Willis in 1929 and again served as acting head of the college in 1944. Despite her experience and outstanding record of service, she was never considered to be the permanent headmaster, and in 1944, the board of education did not grant her the more appropriate title of interim president.

Dr. M. Ernest Townsend served as principal of Newark Normal School from 1929 to 1937. He oversaw the transition from a normal school to a college and was named the first president of the institution. A student of the noted educational theorist John Dewey, Townsend emphasized progressive ideals of mass education and attention to student emotional needs as well as learning. Townsend oversaw fundamental curriculum changes during his tenure; his untimely death at the age of 50 cost the college a valued leader at a crucial moment.

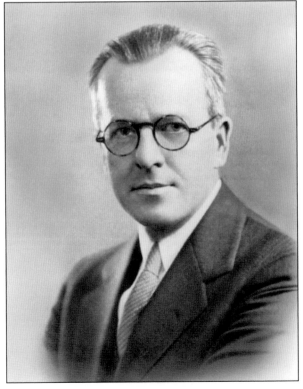

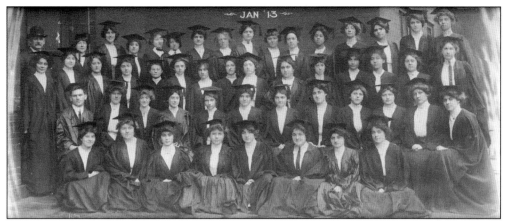

This photograph of the graduating class of 1913 highlights many of the characteristics of the school at this time. Note especially the presence of one African American and the very few men among the graduates. This class also included Anita Breuing, who would join the physical training department in 1915. There she met her husband, the head of that department, Joseph D'Angola. Although she left the faculty briefly after her marriage (in keeping with the custom of the time), Anita D'Angola returned a few years later. She and her husband each gave nearly a half-century of service to the school.

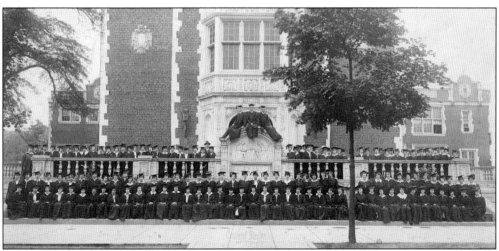

The *Pedages* issue from the spring of 1915 included the following "Farewell to Our Graduates:" "To-day you close the books you have studied; to-day you say farewell to study room and class. Your books will become food for the tooth of Time, dust will cover them and age will wither them. But the greater school you now enter has many books from which you shall glean lessons—bitter and sweet."

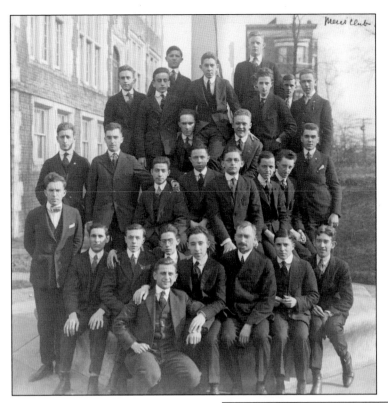

The Men's Service Club was organized in 1916. The men planned to hold a play, offer morning entertainment, and host a banquet during the upcoming academic year. All students were invited to attend these events, so they were not seeking to exclude women. Given the relatively small number of men enrolled at Newark State in this era, the men may have been seeking a means of connecting with each other. This photograph was taken in 1917.

After the Great War, the state urged schools to compile the ways in which they had participated in the war effort. The *War Bulletin*, published in 1920, included an introduction by Principal W. Spader Willis, who wrote: "The call fanned the patriotism of the faculty and students of the State Normal School at Newark into a blaze. . . . They collected thousands of dollars, made thousands of useful articles, and gave thousands of hours in various war activities with unhesitating cheerfulness, loyal determination and generous devotion." This patriotic illustration lists the names of the men and women from the campus who served in the war.

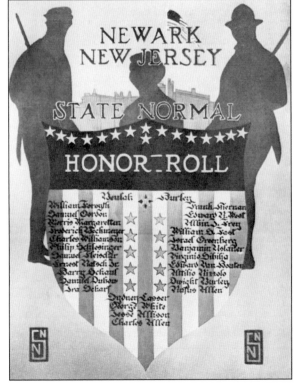

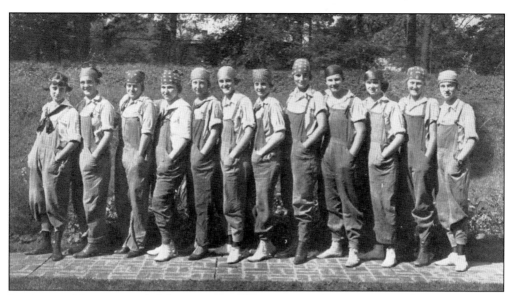

During World War I, men left farms to actively serve or work in war-related factories. Farmers needed help to continue producing food for the men in service and the people suffering in Europe. The *War Bulletin* featured this photograph of 12 of the 24 young Farmerettes of Newark State who worked the summer months on a farm in Summit, New Jersey, where they "went to their task as to a sport." From left to right are Clara Kleinhaus, Frances Geiser, Caroline Soular, Clarese Linder, Edna Von den Steinen, Catherine Burns, Marie Millering, Louise Rauter, Dorothy Stead, Gladys Brown, Bertha Schlee, and Marion Burns.

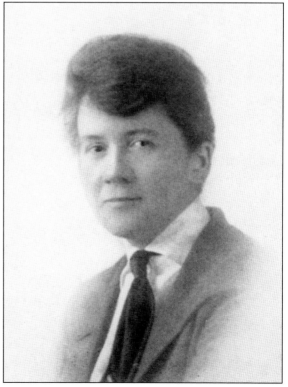

Beulah A. Hurley, head of the Economics Department, took a leave of absence during World War I to serve in Europe with the Society of Friends (Quakers). Between March 30, 1918, and December 18, 1919, Hurley served and wrote several letters back to the faculty and students of Newark State Normal School. She was stationed in France and Belgium, where she aided refugees. On campus, a German helmet was used to collect money that was sent to Hurley. She used the money to host a Christmas party for Belgian refugees, including over 500 children, where they were entertained and gifted stockings full of toys, oranges, and candy.

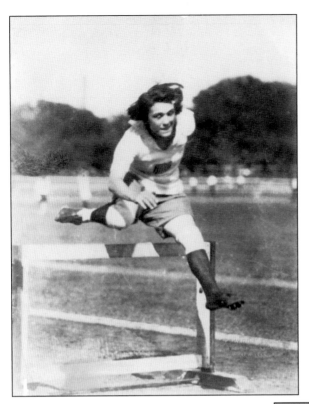

Camille Sabie set a world record in the 110-yard hurdles and won an additional gold medal in the standing long jump and a bronze in long jump at the 1922 Women's World Games in Paris. The games were held because the International Olympic Committee refused to include track events for women in the Olympic Games until 1928.

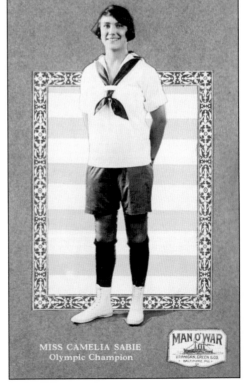

MISS CAMELIA SABIE
Olympic Champion

MAN O' WAR

Camille Sabie graduated in 1922 with a degree in elementary education. Students and faculty raised $700 to send her, along with Joseph and Anita D'Angola, the school's physical education teachers, to the Women's World Games in Paris. Camille credited Joseph D'Angola with getting her involved in track and field. She is shown here in an advertisement for Man O' War athletic wear.

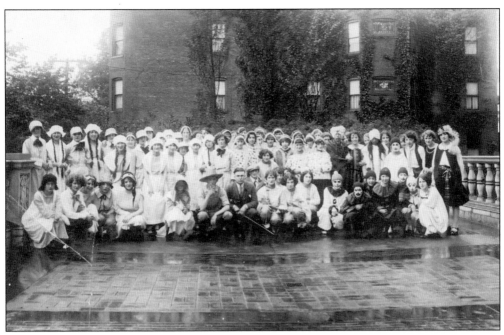

The class of 1925 performed a radio variety show for its younger classmates and faculty members. Nearly 500 attended. Twelve acts were broadcast, including Chinese maidens singing, a clown dance, a Dutch dance, Mah Jong girls, and a comic jazz band. There was also a fashion show, a revue of movie stars, vocal solos, and a "Rube Sketch."

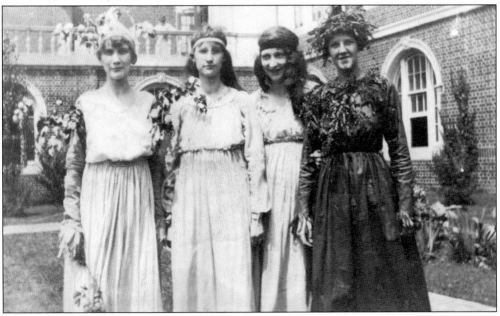

Newark State students working with the kindergarten classes on campus would frequently put on costumes and perform for the children. This was rooted in the ancient spirit of play. Many shows included a fairy dance. Performances at Halloween and Christmas were especially popular. Descriptions of performances were included in the 1924 yearbook, the *Blue and Silver*.

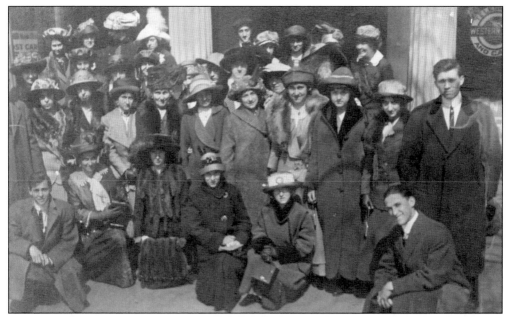

This is a group of Newark Normal students visiting Washington, DC. A Washington trip from March 1913 is described in *Pedages*. Their adventures included a reception in the East Room of the White House by Pres. Woodrow Wilson, who had been inaugurated only a few days before. The group was chaperoned by Agnes V. Luther, the botany teacher.

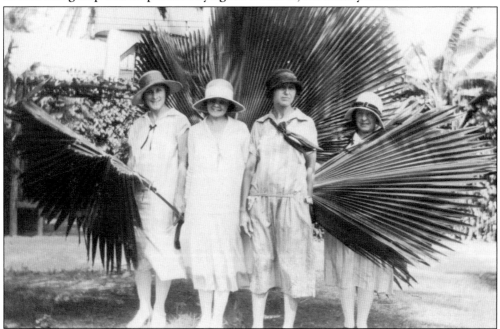

This picture was taken on a school trip to the island of Jamaica in 1925. The four students are Elsa Balken Decker, 15; Irene Hemming; Sarah Watson, 14; and Elsa Huebner Urban. The trip, like many other overseas trips, was organized by A. Luella Seager. Although overseas travel would have been out of the ordinary for many Americans at this time, they were annual events for students at Newark Normal School.

A. Luella Seager, supervisor of student teaching, is pictured here on a ship to Bermuda in 1928. Seager started the school's overseas travel program to expose Newark State students to European and other cultures. In conjunction with programs in literature and art, graduates gained considerable experience of foreign countries they could bring to their classes.

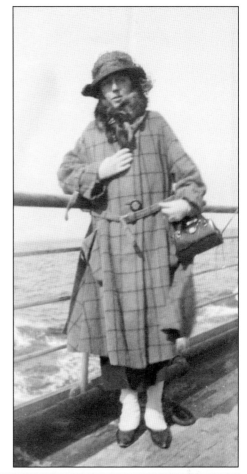

The July and August 1937 European travel course at NSTC was also led by A. Luella Seager. The tour included visits to England, Norway, Sweden, Denmark, Holland, Belgium, and France. Scandinavian countries were emphasized because of their advanced social planning and sophisticated education system as well as the unsurpassed natural beauty. This photograph shows female students visiting Norway in 1937.

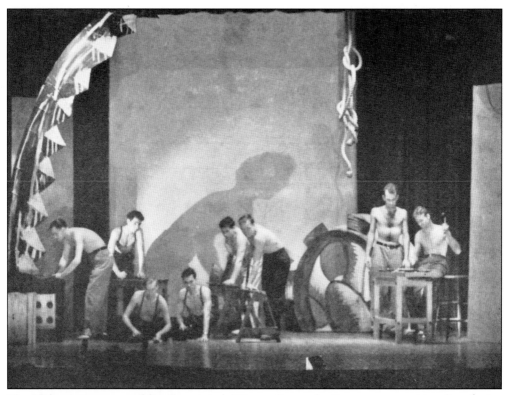

The 25th anniversary publication stated: "Dramatic productions are an outstanding factor of the extra-curricula life of the college." Under Principal (and later President) Townsend, fine arts instruction grew to include theater and puppetry, as well as other fields of study including community planning and home design. Strong leadership by the fine arts faculty ensured that those programs flourished even in the difficult budget environment of the 1930s. This picture was taken by talented student photographer William Cotton.

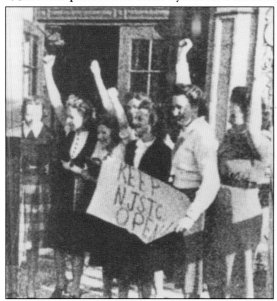

During the Great Depression, enrollment declined at the college. In January 1939, the New Jersey state legislature voted to close the school by shutting off its annual appropriation of $211,000. Essex County senator Homer C. Zink suggested that the building be reappropriated to house New Jersey state government offices. Alumni, faculty, and students gathered in protest and collected over 30,000 names on petitions to keep the school open.

Three

NEWARK STATE GOES TO WAR

In the wake of the December 7, 1941, Japanese attack on Pearl Harbor, Newark State Teachers College president Roy L. Shaffer released a statement to the college community in the December 12 issue of the *Reflector* stating that "We as a college have been shocked by what has happened, but it is the kind of shock that unifies us in thought and action. This attack on us will mean a total war. What the terms total war will mean to us as a college is not clear to us at this moment. Consequently," he continued, the college would be guided by national, state, and local councils of defense.

The campus community, as Shaffer promised, was unified in responding to the United States' entry into the war. Many NSTC men and women joined the armed services, and many more supported them on the home front. And campus life changed accordingly.

With the military hungry for college graduates, NSTC implemented an accelerated curriculum to allow students to earn their degree in only three years. The college also introduced new physical education courses to improve student physical fitness. As growing numbers of male students volunteered or were drafted into military service, female students sought ways to preserve NSTC traditions and keep typically male clubs and sports teams active. They also supported the war effort by volunteering for the Red Cross, knitting hats and gloves for soldiers overseas, collecting food for war-torn countries, and spearheading War Bond drives on campus.

The effects of the war on the lives of the NSTC students and campus is uniquely documented in more than 800 letters, cards, and newspaper clippings collected and preserved by NSTC librarian Nancy Thompson. Thompson wrote letters to NSTC male and female students and alumni serving in the military and invited them to write back to her, sharing their news and experiences. Over the course of the war, over 180 did write back. Thompson and Lenore Vaughn-Eames compiled their news into a newsletter titled the *Serviceman's News*, which they mailed to NSTC student soldiers all over the world. Thompson compiled the letters she received in a scrapbook that tells the stories of lives changed irrevocably by World War II.

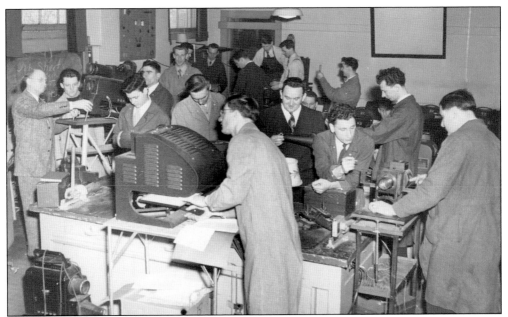

Although many students struggled to find jobs during the Depression, the onset of World War II led to a tremendous demand for teachers, as many elected to join military service or work in industry. Moreover, students majoring in industrial arts found themselves in especially high demand to work in military industries and as mechanics and trainers in the armed forces.

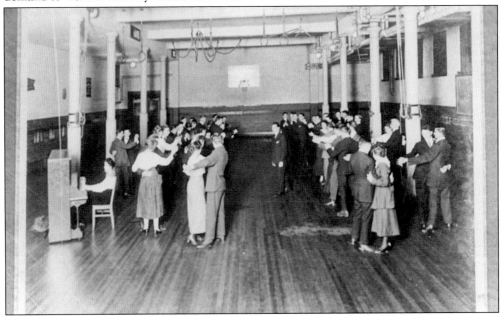

Social dancing was organized in the college's gymnasium at lunch hour on Tuesdays and Thursdays in December 1939. Formal dancing grew in popularity during the war years. As increasing numbers of male students volunteered or were drafted into the armed services, the number of male students, never more than 25 to 30 percent of the student body, declined dramatically. So NSTC reached out to area schools. Dancing and the lack of male students on campus also led to tighter bonds with the predominantly male Newark College of Engineering in the 1940s.

A graduate in the class of 1940, Achilles "Al" D'Amico served as student conductor of the college choir and the instrumental ensemble. His page in his senior yearbook noted: "He leaves Newark with the name 'D'Amico' synonymous with music." He was working as a music teacher when he enlisted in the Army, and was wounded in Europe in November 1944.

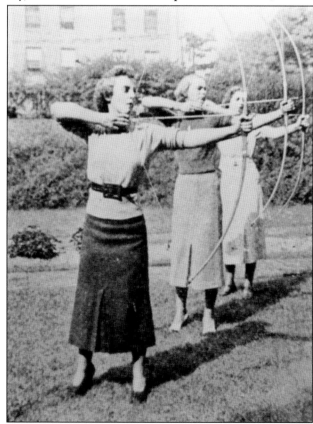

The Sagittorii Society was started in 1938 in response to the interest in archery by many students. To qualify, a student had to take archery with Joseph D'Angola, the head of the physical education program, and then pass a shooting exam. Students could then participate in shooting sessions, an annual tournament, and competitions with other schools. The club sparked an interest in woodworking too, as many students used the shop to construct their own equipment.

Ready to Defend Their Homes

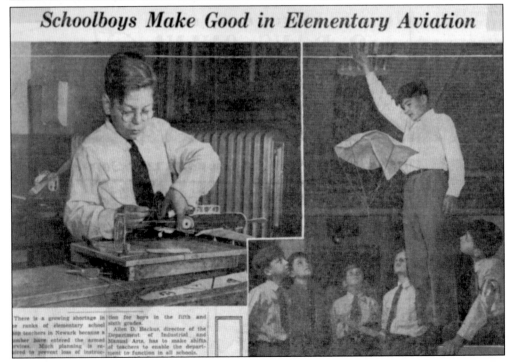

Even before the Japanese attack on Pearl Harbor, the escalation of fighting in Europe led civilians and NSTC students, male and female, to seek training in military skills. This photograph, published in the *Newark Star-Ledger* in May 1941, depicts Ruth Rader (left) and Theodora Yospin, two NSTC students, at rifle practice in front of the NSTC building.

As growing numbers of male teachers, especially in industrial arts, entered military service, local schools created a rotating substitution of teachers to ensure that basic education in the industrial arts continued. NSTC graduate Ira Rosenberg, who went on to serve in the Army, developed a unit on elementary aviation. His students are shown building model airplanes and learning about parachutes in an article in the *Newark Evening News* from November 23, 1942.

Schoolboys Make Good in Elementary Aviation

There is a growing shortage in the ranks of elementary school teachers in Newark because a number have entered the armed forces. Much planning is required to prevent loss of instruc- tion for boys in the fifth and sixth grades. Allen D. Backus, director of the Department of Industrial and Manual Arts, has to make shifts of teachers to enable the depart- ment to function in all schools.

This map hung on the wall in the main hallway of the NSTC school building. Maintained by librarian Nancy Thompson, it showed where each NSTC student and alumnus was stationed around the globe during World War II. NSTC students served in every theater of war.

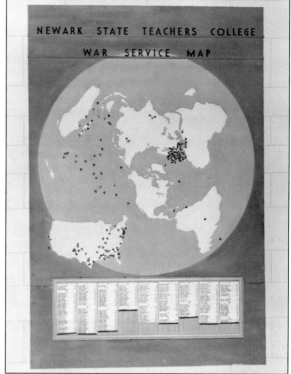

In addition to mapping the location of students stationed around the world during the war, NSTC also displayed a banner in the central hallway of the school building honoring those injured and killed in action. Seven students and alumni lost their lives over the course of the war.

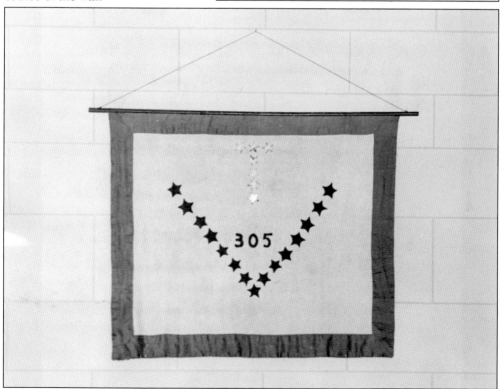

We here at NEWARK STATE wish you a MERRY CHRISTMAS and a HAPPY NEW YEAR...... and await YOUR RETURN

SONGS FROM THE PRODUCTION

COLLEGE DAZE

Words and Music by
RALPH P. SOZIO

PRICE
75¢

PUBLISHED BY
RALPH P. SOZIO
99 CLIFTON AVENUE
NEWARK, N. J.

During the war years, NSTC faculty and staff sent an annual Christmas greeting to former students and alumni in military service. For their part, the letters of the male students sent to Nancy Thompson and others at the college often asked about the female students on campus and frequently asked to be remembered to one the soldier recalled with special fondness.

College Daze, a student-produced variety show, was one of the most memorable events in the college experience of the NSTC students who witnessed it. Many used the phrase "College Daze" as a shorthand for their time at NSTC and in recalling their undergraduate experiences wherever they found themselves scattered around the globe by the war. It demonstrated the unity that had been forged in wartime at NSTC. As the editor of the *Reflector* wrote, "we don't have to spend time telling you how wonderful it was. Because you know."

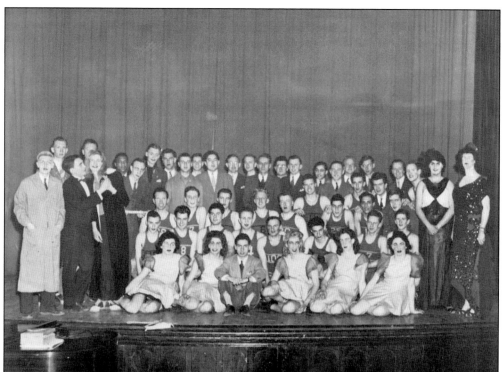

Written and produced by NSTC student Ralph Sozio, *College Daze* was performed by a number of NSTC students (27 in total) shortly before they headed off to military induction and basic training at Fort Dix, New Jersey. Preparations for the show were kept secret by Sozio and the performers, who thrilled their classmates with a series of songs and sketches. These images feature the full cast and crew of *College Daze*. Writer and producer Ralph Sozio is seated in the center of the group above. Described by Nancy Thompson as "Never very strong," Sozio battled a series of illnesses including mumps and scarlet fever during his time in the service. The talented student died of rheumatic fever in June 1945. One of Kean's dorms is named in his honor.

Pre-Induction Fling
Men at Teachers College Take Show-Girl Parts Before Joining Armed Service

From left: Russell Herbert, Gerald Ferraro, Paul Souls, James Gloob, Cecil Pollack strip out.

George McCarthy, fan dancer, tells the boys about it.

George Clausen making up for his Veronica Lake role.

One of seven NSTC students who died in military service during World War II, Peter Cummins served in counter-intelligence and was killed in action in Germany in April 1945. Like many NSTC students, Cummins was sent to officer candidate school because of his academic skill and college education. At a time when only about 10 percent of Americans attended college, the men and women of NSTC stood out in military service because of their academic backgrounds.

Started in 1926 as an effort to provide serious coverage of news and events at the normal school, the *Reflector* replaced the *Pedages*. In June 1942, the *Reflector* began to publish biweekly instead of monthly. The students bragged that theirs was the only college paper in New Jersey to do so.

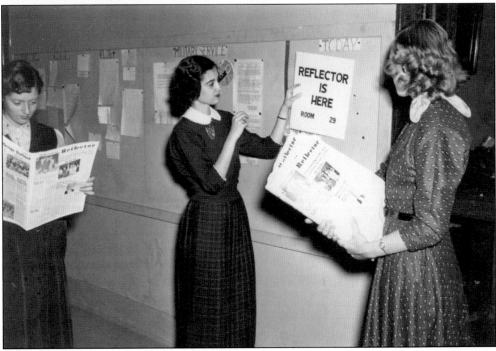

"Keep 'Em Reading" was the goal of the Victory Book Drive, which aimed at collecting 500 books for Army and Navy bases, posts, and ships. This campaign was not unlike collections of scrap metal and other important resources as part of the war effort on the home front. The Library Council, which sponsored the campaign, tapped into patriotism and urged NSTC students to "choose the book you would most like to keep and turn it in to the Victory Book Campaign."

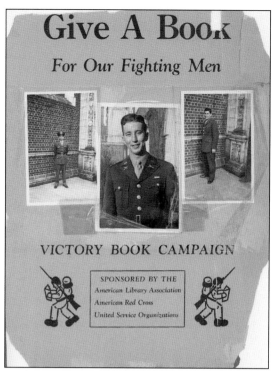

The NSTC campus worked with the larger Newark community to meet the needs of the nation at war. In November 1941, vice president of NSTC Bertha Kain organized a group of 40 "girl students" from NSTC to assist Newark's Red Cross in recruiting efforts in the city.

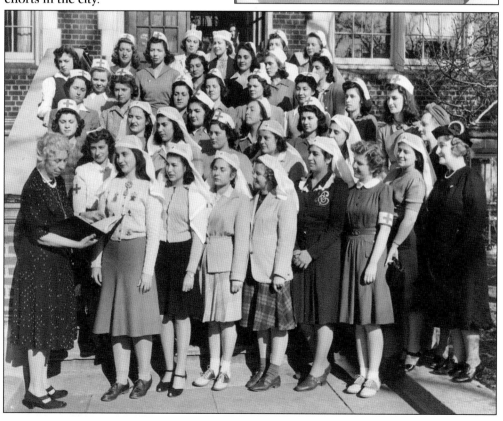

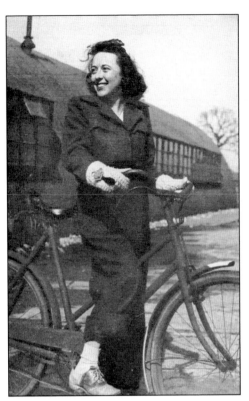

Margaret O'Mara, shown bicycle riding at an Eighth Air Force base in England, was one of several NSTC female students to volunteer in the war effort by joining the WACs, the WAVES, or the Red Cross. A 1940 graduate with a degree in primary education, O'Mara taught kindergarten in Millburn before joining the American Red Cross in 1944. While in the Red Cross, O'Mara worked as a recreational staff assistant in England and Germany.

Among the industrial and fine arts taught at NSTC was photography. NSTC student Robert Kaeppel (class of 1944) was sent to the Air Forces Technical School, where he was trained in aerial photography used for military reconnaissance. Stationed in Guam, Kaeppel gathered photographic intelligence on the Pacific islands. He sent this photographic Christmas card of himself in Guam to librarian Nancy Thompson.

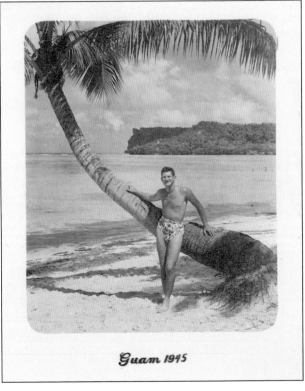

Guam 1945

A member of the NSTC class of 1941, Sidney Leigh enlisted in the Army and served in a bomber crew. His plane was shot down over Germany, and he spent two years in a German POW camp before being freed and returning to Newark in 1945.

Fraternities, sororities, and other student groups took every opportunity to raise funds to support the war effort. In this photograph, Pres. Roy Shaffer is shown purchasing a Defense Stamp, which served as a ticket to the Defense Dance held by the Nu Sigma Phi fraternity.

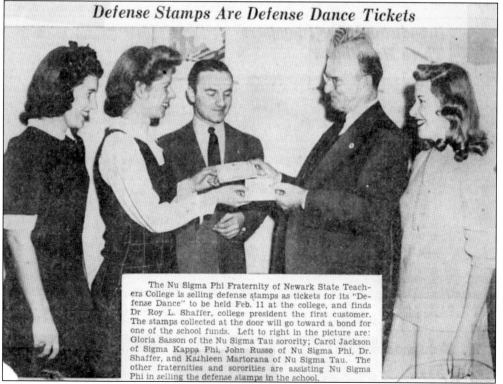

Defense Stamps Are Defense Dance Tickets

The Nu Sigma Phi Fraternity of Newark State Teachers College is selling defense stamps as tickets for its "Defense Dance" to be held Feb. 11 at the college, and finds Dr Roy L. Shaffer, college president the first customer. The stamps collected at the door will go toward a bond for one of the school funds. Left to right in the picture are: Gloria Sasson of the Nu Sigma Tau sorority; Carol Jackson of Sigma Kappa Phi, John Russo of Nu Sigma Phi, Dr. Shaffer, and Kathleen Martorana of Nu Sigma Tau. The other fraternities and sororities are assisting Nu Sigma Phi in selling the defense stamps in the school.

UNITED STATES TREASURY DEPARTMENT
CITATION

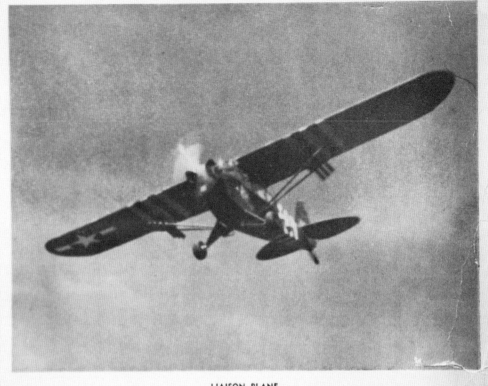

LIAISON PLANE

This is to certify that the above equipment has been presented to the Armed Forces of the United States through War Bond purchases made by NEW JERSEY STATE TEACHER'S COLLEGE

NEWARK, NEW JERSEY

Henry Morgenthau Jr.

SECRETARY OF THE TREASURY

DATED FEBRUARY 24, 1945

War Bond drives were a regular part of campus life, just as they were in communities across the country during World War II. War Bonds were used as admission tickets for dances and other events on campus as students sought to make their own contribution to the Allied victory. As this citation shows, the campus community proved extremely successful in its efforts.

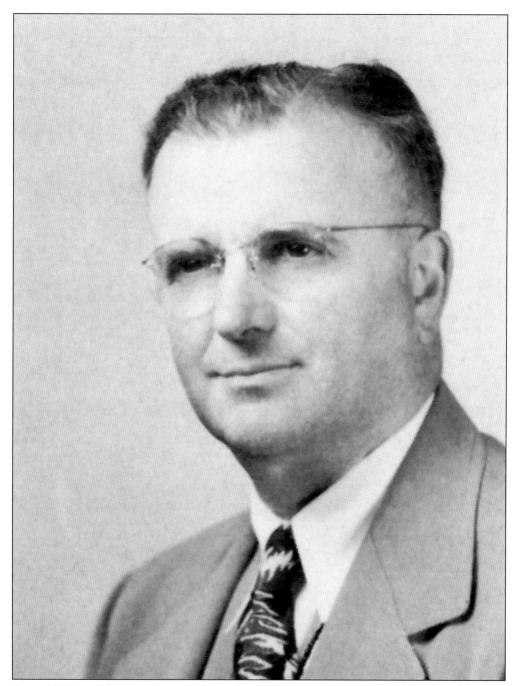

From 1918 until his retirement, physical education teacher Joseph D'Angola was a vital presence on campus. In 1942, he introduced daily conditioning or "toughening" classes. While D'Angola had coached talented athletes like Camille Sabie to compete internationally, he believed that an overemphasis on competitive team sports had led to a general decline in student fitness. He offered daily classes at 8:00 a.m., through which he observed an increase in student fitness for military service through the building of muscle, especially in the chest and calves, and loss of excess weight around the waist.

On February 12, 1954, the NSTC Alumni Association honored Nancy Thompson, NSTC librarian from 1914 to 1957, for her "untiring efforts in maintaining detailed records" related to alumni of the school. She was presented with a blue leather album into which she placed the hundreds of letters sent to her by student soldiers during World War II. The album and its contents are preserved in the Kean University Archives and Special Collections.

Four

THE MOVE FROM NEWARK TO UNION

For its first hundred years, Kean University was based in Newark and was known as Newark State Teachers College. As time passed, the city grew, the residential neighborhood housed fewer families, and trolley lines were replaced with automobiles. The college's single building was small and in need of repair. By the late 1940s, the school could no longer meet its demands and had two choices: close or move.

Eugene Wilkins, the college's president, persuaded the state to relocate the school on a new campus. In the spring of 1951, the New Jersey legislature authorized a referendum to provide a bond issue of $15 million for teacher-college expansion. In November 1952, the City of Newark received $3.7 million to relocate the college at a new site.

The community, educators, and government officials decided to move the campus to nearby Union Township. The state purchased a parcel of land owned by one of New Jersey's most famous families, the Keans, on March 30, 1954. Fifteen hundred people attended the ground-breaking event on April 11, 1956. The big move to Union took place on an unexpectedly snowy day, March 14, 1958. The official dedication of the campus was held on October 4, 1958. The campus expanded from a single building on one acre to five buildings on 120 acres. On July 1, 1958, the name was changed again to Newark State College. The campus was now ready to meet the needs of its students for the next hundred years.

The original five permanent buildings included the L-shaped Townsend Hall, with two levels of classrooms and one level for administration; the student center, with a cafeteria, the little theater, a snack bar, and separate lounges for students and faculty members; the coral-colored library, which was lit from white plastic ceilings (the library was originally located where the Center for Academic Success building is today); and the central power and heating plant, with its colorfully painted pipes and large glass windows where visitors could admire the modern space. The buildings were spaced far apart to allow for future growth. See chapter eight for photographs and information about the history of the Union campus.

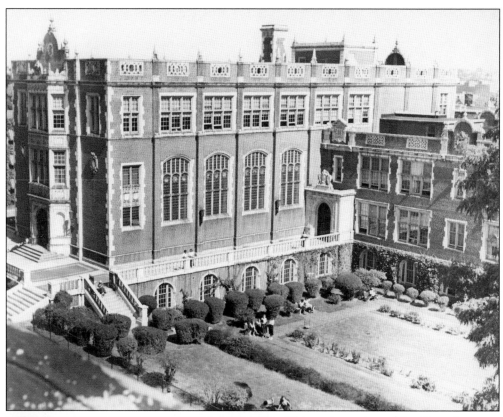

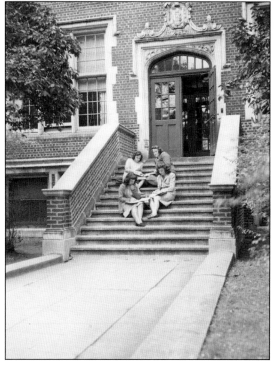

This mature view of the Newark campus includes the tall shrubbery in the sunken garden. The neighborhood was changing, and there was no room to expand. The commissioner of education, John H. Bosshart, wanted to close Newark State Teachers College and expected its faculty and students to merge with Montclair. A new commissioner, Frederick M. Raubinger, was less eager. The college would not close, but it needed to find a new location.

Here, a group of students is gathered on the steps. While no longer required to wear white gloves, women were expected to wear skirts or dresses, and the men had to wear jackets. The 1964–1965 Student Handbook was the last to state that women were not permitted to wear slacks or shorts, men could not wear shorts, and "students inappropriately attired may be denied admittance to the campus."

Note the beanies on the heads of some of these students sitting outside the Newark building. Beanies were a popular national trend in the early 20th century, and were reintroduced on campus in the 1960s. The hats, often made from felt, were required for freshmen during the first few weeks of the fall semester.

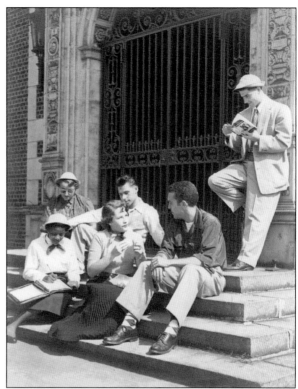

In the years after World War II, the student population not only rebounded, but grew tremendously, as did the curriculum. But NSTC continued to flourish in educating future teachers of art.

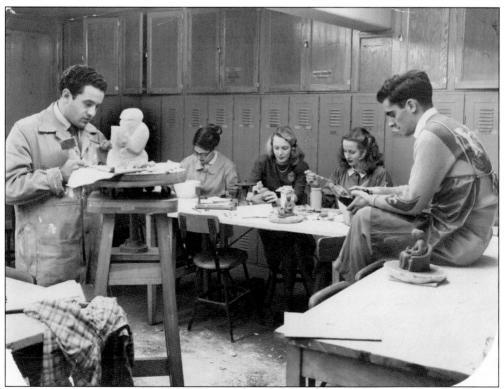

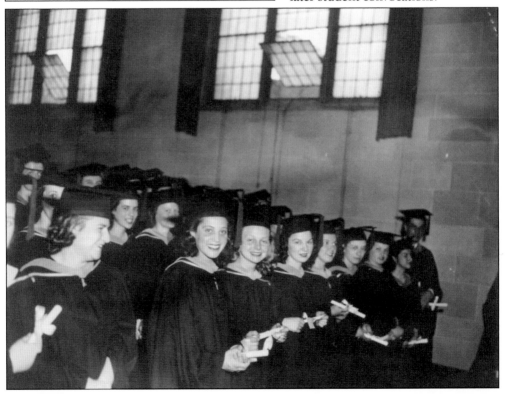

A resolution for a new campus and buildings was created by librarian Nancy Thompson. Over 90 pages of petitions were signed by students, faculty, staff, alumni, and community members. It was clear that Newark State had outgrown its current building, and the community was committed to moving to a new campus. Thompson retired in 1957 and sadly never visited the new campus. The library was named in her honor.

A final convocation assembly occurred in Newark on February 14, 1958. Speakers included former leaders of the college Bertha R. Kain and Dr. John B. Dougall; Dr. Elizabeth Huntington, president of the alumni association; and Glennys G. Grenda, president of the student organization. The event also included an orchestra, singing, and prayer. This photograph is not dated but shows one of the later student convocations.

Maps were studied to find a local area that could accommodate a college campus. The new location couldn't be too close to other teacher colleges in Montclair or Paterson. Union was close and had a few pockets of open land. Here is a southern view from the Newark location looking in the direction of the new campus in Union.

Pres. Eugene G. Wilkins served from 1950 to 1969. He was the first president of the college to be selected from the school's faculty. Shortly after his term began, the state announced plans to close the campus. Instead, he and others worked together to find a new location. Under his watch, the number of students increased fivefold.

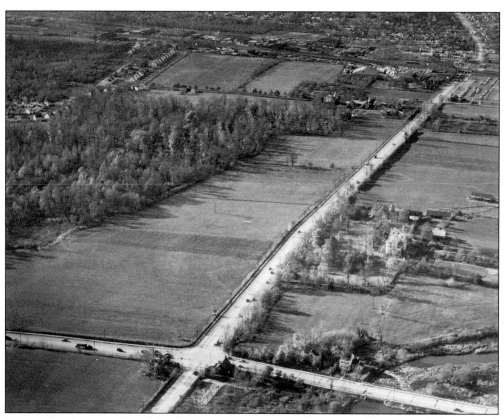

Among the sites considered for the new campus were Suburban Golf Course, Galloping Hill Golf Course, Bottle Hill Golf Course, and Weequahic Park in Newark. The Kean tract was the preferred site. It took multiple attempts to seal the deal. First, New Jersey commissioner of education Frederick M. Raubinger intended to set up a meeting with President Wilkins and the Kean family. Wilkins arrived but was chased off the property, as Raubinger forgot to tell the Keans about the meeting. Here is a 1950s view of Morris Avenue looking west toward Union.

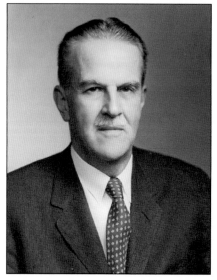

Next, Wilkins corresponded with Robert Winthrop Kean, to which he received a polite answer of no. Robert Winthrop Kean (1893–1980) grew up on the Kean family estate in Union. His father, Sen. Hamilton Fish Kean, built Green Lane Farm across the street from the family home, now Liberty Hall. Robert represented New Jersey for 10 terms in the US House of Representatives, from 1939 to 1959. Finally, alumnus Marion Quinn Dix put Wilkins in touch with E.J. Grassmann, counselor to the Keans, and began what would be successful negotiations.

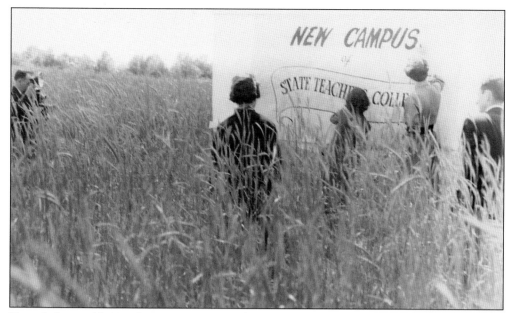

Negotiations with E.J. Grassmann, counselor to the Kean family, resulted in the eventual sale of 120 acres of Green Lane Farm on March 30, 1954, for the new campus. The price was $495,000, below market value, with the understanding that the property could only ever be used by the college. This photograph, taken in 1954 in a field of golden rye, shows students and alumni painting a "New Campus of State Teachers College" sign.

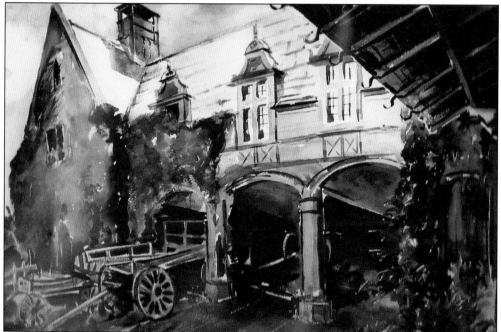

This watercolor depiction of the Green Lane Farm buildings was completed in the years before the college moved to Union. Union County artist Hela Balin used to come to the farm to do sketches and paintings. She allowed the university to create prints of her Green Lane watercolors at the time of the dedication of a renovated Kean Hall in 2003.

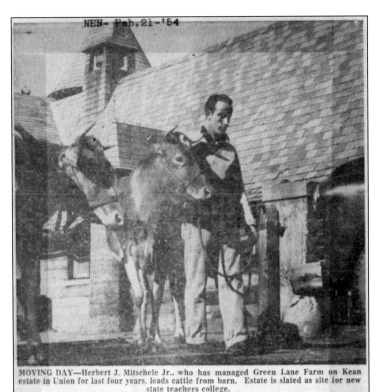

NEN- Feb.21-'54

MOVING DAY—Herbert J. Mitschele Jr., who has managed Green Lane Farm on Kean estate in Union for last four years. leads cattle from barn. Estate is slated as site for new state teachers college.

The Kean estate farm closed in March 1954. This image from the *Newark Evening News*, dated February 21, 1954, shows farm manager Herbert J. Mitschele Jr., who leased the property for the last four years. In the article, he says that 43 milking cows and 17 heifers were relocated and that he would join his father's construction company.

In 1957, the school moved to its third location: first at Newark High School, second at the former Kearny homestead, and now on part of the Kean estate. This photograph was printed in the *Newark Sunday News* on February 23, 1958. The article, "Future Profs Get New Campus," by Robert L. Degenhardt, noted that the school was one of only a few in the country to completely relocate.

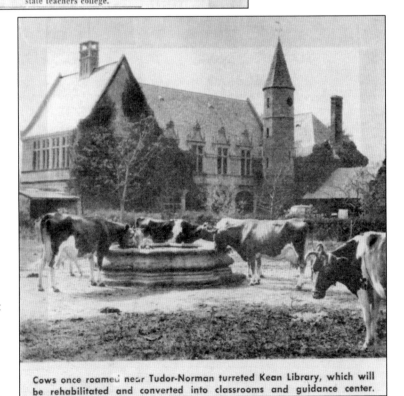

Cows once roamed near Tudor-Norman turreted Kean Library, which will be rehabilitated and converted into classrooms and guidance center.

60

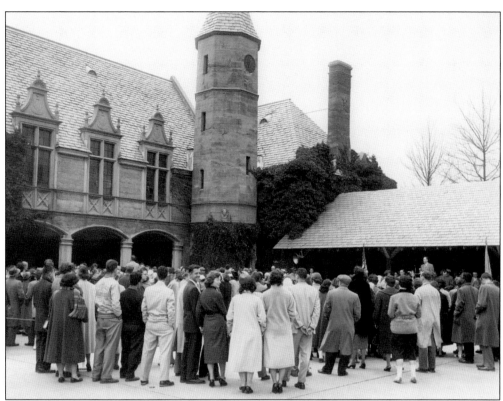

Much consideration was given to the look of the new campus. The Kean Library at Green Lane Farm was beautiful, but it would be too costly to match the new campus with that style. Like the other teaching colleges in the state, the school was expected to become a multipurpose liberal arts college. The new campus had plenty of room for growth. Here, a crowd gathers for the ground-breaking ceremony.

Ground-breaking for the five new buildings in Union took place on April 11, 1956. A reception for invited guests and faculty took place outside the Kean Library at Green Lane Farm, and a coffee hour hosted the entire student body. Pictured here are, from left to right, Margaret McCarthy (class of 1956), student council president; President Wilkins; and Ernest C. Shawcross, alumni president.

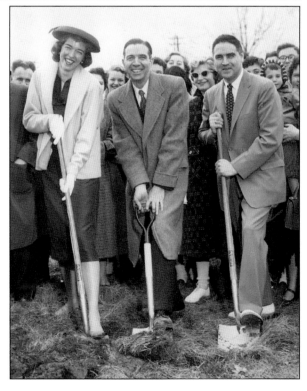

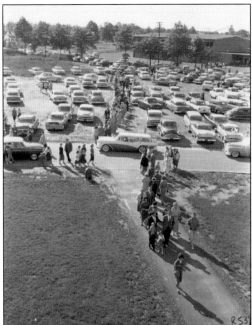

In the October 15, 1953, *Elizabeth Daily Journal*, Dr. Wilkins wrote, "the college's 8,000 member Alumni Association also heartily recommended the change and has warmly endorsed the Kean tract." About 1,500 people attended the groundbreaking ceremony. Formal parking lots were not yet part of the campus.

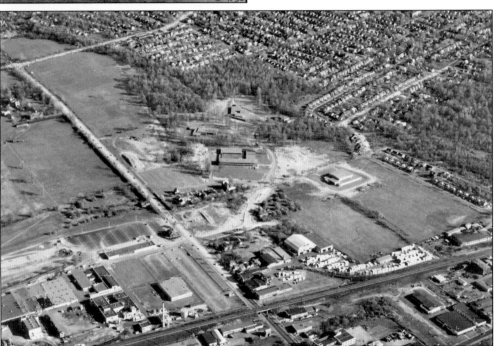

Mayor F. Edward Biertuempfel of Union was quoted in the March 31, 1958, *Elizabeth Daily Journal* as saying that "Union Township now has everything . . . we thought we were shooting at the moon. . . . We are happy at this final page in the book. The college will do a lot for the entire area." Although the relationship with the town of Union has not always been smooth, the university contributes enormously to the cultural and intellectual engagement of the community. In this view, the portion of Morris Avenue between the train tracks and North Avenue is captured.

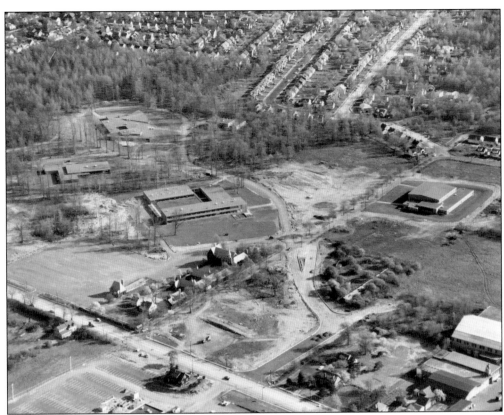

In October 1957, the New Jersey Board of Education adopted a resolution to change the names of all the teachers colleges to reflect their postal locations. But as Union Township, in Union County, already had a Union Junior College, the New Jersey State Teachers College at Union was short-lived. On July 1, 1958, the name was changed again to Newark State College.

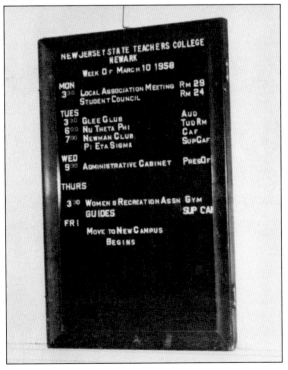

This posted schedule notes that Friday, March 14, "the move to new campus begins." Classes were held that day, but a memorandum went out stating that if movers interrupted a class, "students will be asked to assist in labeling and minor moving operations." The biggest tasks were packaging and moving 36,000 volumes in the college library and moving the Townsend Memorial Organ from the auditorium.

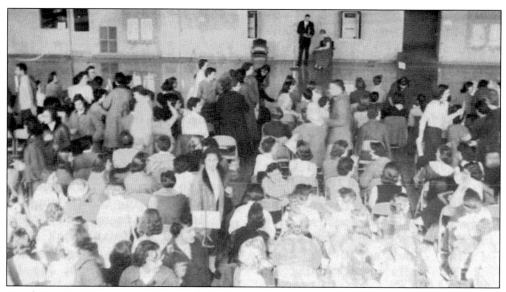

The following Monday, students and faculty were to report to the Union campus and attend an assembly in the gymnasium. A memo stated: "so many people have expressed a desire to move to the new campus, especially the seniors, . . . that the move is being made at this time. The overcrowding of the Newark building and the increasing lack of parking space further indicate the necessity for moving as soon as possible."

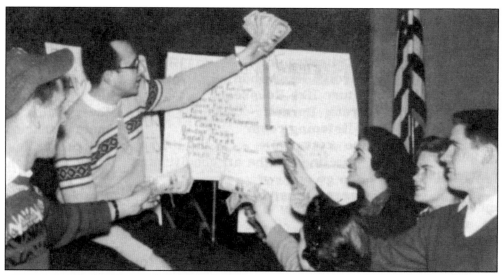

Money raised to build the school did not cover all the amenities students wanted in the new College Center. At the first assembly, students were encouraged to raise $1,000 to purchase, among other things, a hi-fi set and records, a chess set and games, typewriters, furniture, cabinets, and shrubbery. They collected $810 in the following week.

On September 28, 1958, from 2:00 to 4:00 p.m., the campus invited the community to an open house. The *Elizabeth Daily Journal* announced the event in a 10-page supplement. An estimated 10,000 to 12,000 people visited, many more than expected. This is the front page of the supplement, which included many articles about the campus, as well as advertisements welcoming and marketing to students, faculty, and staff.

NEWARK STATE COLLEGE

NEWARK STATE COLLEGE
'Open House'
Tomorrow (Sunday)... 2 P.M. to 4 P.M.

WELCOME NEW NEIGHBORS! Tomorrow, Sunday, our Newark State College neighbors are giving us the opportunity to visit "their home" and, at the same time, extend Union County's traditional hospitality. Open House hours are 2 P.M. to 4 P.M. Tour the campus ... see the college ... meet our new neighbors. It will be a pleasant afternoon for the entire family.

This view of the library is from the site of present-day Willis Hall. Note the cars parked in front of the building and the simple bridge crossing Trotters Creek.

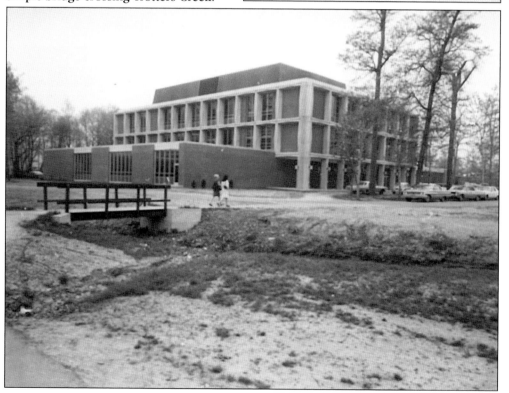

Named for the school's seventh principal and first president, Townsend Hall was one of the original buildings on the Union campus.

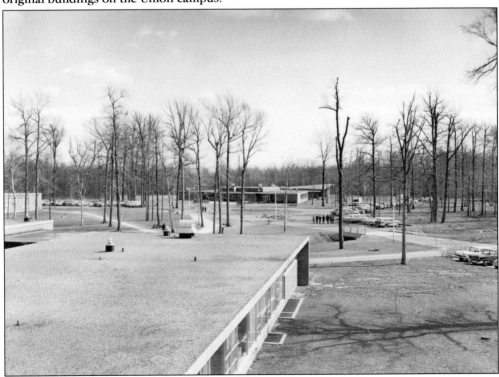

This view is from the second floor of Townsend Hall, looking towards the Student Center. The pathways are the same, but the view has changed. Note that cars were permitted to park much closer to campus.

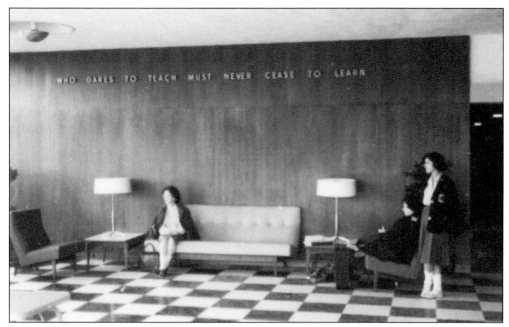

The original motto for the school, created by John Cotton Dana when the new building was constructed, continued to be used at the new location. Here, it is displayed in the lounge in Townsend Hall. It remained the motto until the curriculum expanded to degrees not related to teaching in 1973. At that point it changed to a derivative of the original, *Semper Discens*, "Always Learning."

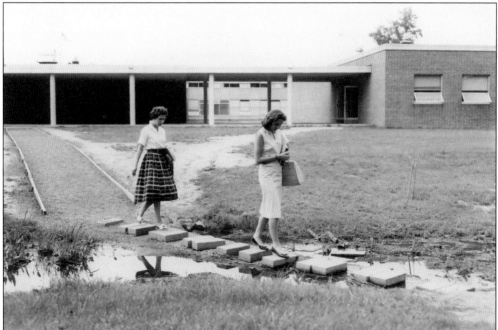

In this photograph, women cross a makeshift pathway over Trotters Creek leaving Townsend Hall. Technically state property, no permanent structures are allowed at the edge of the creek. There has been quite an evolution of bridges over the years.

In 1947, the college introduced a curriculum for the teaching of handicapped children. It was the first in the state to have such a program. On the new campus, students had access to state-of-the-art technology in their fields of study. Less than one week after relocating, the college hosted a meeting of the Speech Association of New Jersey. It was the first of many institutes that would take place in Union.

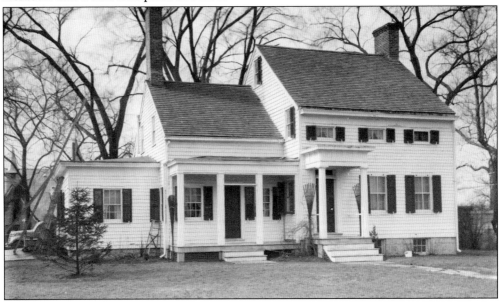

The Townley House was purchased by Hamilton Fish Kean in the 1910s, right around the time when construction on Green Lane Farm began. Architecturally quite different from the French Renaissance structure behind it, this modest farm house was originally built by James Townley around 1790. The Townley House was recorded by the Historic American Buildings Survey in 1938 and was listed in the National Register of Historic Places on May 14, 1979.

Five

NEWARK STATE
IN THE 1960s

As the 1950s ended and the 1960s began, Newark State College continued the growth that started in the decade of the presidency of Eugene Wilkins. Although a genteel man, Wilkins had successfully fought off an attempt by the state early in his administration to close the college by merging it with another. He was the first Newark State president to hire a black faculty member, music professor James Dorsey, followed by health professor Joseph Darden. Wilkins also was responsible for bringing both Dr. Martin Luther King Jr. and Dr. Allison Davis to campus to address issues related to segregation.

First as an acting president for a year in 1969–1970 and then as a permanent one, his successor, Nathan Weiss, moved quickly to widen the breadth of academic programs offered at the college. In doing so, Weiss initially faced strong resistance from the New Jersey Department of Higher Education and its chancellor, Edward Hollander. He won a bitter struggle to have the first non-education master's program approved, a master's degree in liberal studies. Undergraduate programs in computer science, management science, and allied health fields followed.

In 1972, Weiss appointed a committee to suggest changes to the school's name. He appointed the President's Committee on Name Change after an earlier committee failed to complete its work. This new committee, chaired by the director of field services, Marion Parsons, considered hundreds of names before suggesting two, one of which was Kean College, to the president and board of trustees. In 1973, this name surfaced from the process. It was a fitting tribute to an important and historic New Jersey family. It also made great sense, as the relocated college was now on former Kean property.

The 1960s and early 1970s also represented an era of conflict and division over civil rights, the war in Vietnam, Kent State, and the changing role of students in college governance. Both Wilkins and Weiss had to contend with difficult and changing times. Wilkins protected the interests of the college by skillful negotiation and a calm professional demeanor, while Weiss weathered the considerable turmoil in his presidency and emerged as the forceful, visionary, consensus-building leader the college needed and the times demanded. Both were highly successful. The era they shared was also marked by the campus visit of great leaders such as King in 1961, Davis in the 1961–1962 academic year, and Vijaya Lakshmi Pandit, the first woman to lead the United Nations General Assembly, in 1959.

This was a time of challenge, change, and great growth for a college on its path to finding its multicultural mission and its promising future.

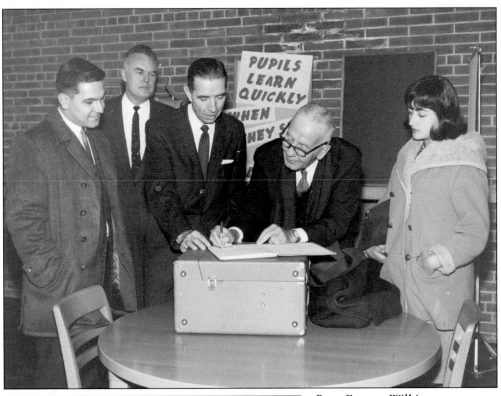

Pres. Eugene Wilkins was an active proponent of learning improvement at the college. From left to right are Joseph Santonello, history professor Donald Raichle, Wilkins, guest speaker John Mason Brown, and Lucille Pace. Kean continued to train future teachers in progressive education as classrooms swelled with the baby boom generation.

Collegefields was an innovative program involving Newark State College faculty and students in providing tutorial and psychological assistance to urban disadvantaged boys. It demonstrated their commitment to improving the lives of children in the city of Newark. Chief among its faculty leaders were Drs. Robert F. Allen, Saul Pilnick, Harry Dubin, and Adella Youtz.

Though historically a commuter college, Newark State College dormitories sponsored social events for students living on campus. On February 13, 1964, a Valentine's Day dinner was held for female students living in the dormitory who had been "pinned" or become engaged, since the fall of the previous year.

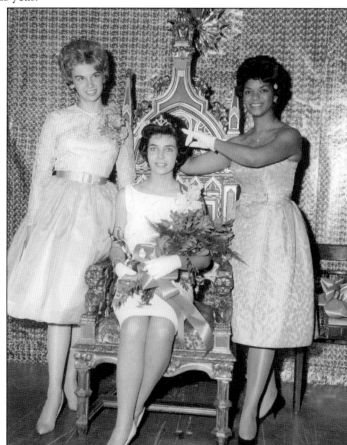

Fraternities and sororities continued to grow on campus. This photograph of (from left to right) sorority members Bev Horn, Peggy Finck, and Weda Gilmore, shows Finck being crowned Inter-Fraternity-Sorority Council Queen for 1961–1962.

In 1958, Florence "Flo" Dwyer, who had built an impressive career in the New Jersey State Assembly, where she successfully introduced the groundbreaking Equal Pay Act, was elected to the US House of Representatives from District 6. She served in the House until 1972. Her congressional papers are housed in the Kean University Archives and Special Collections.

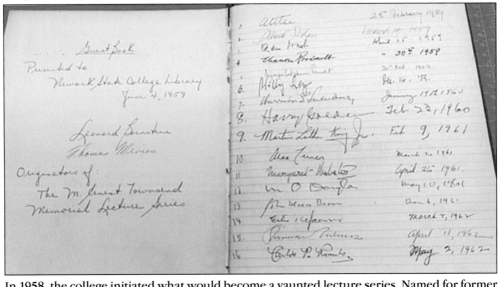

In 1958, the college initiated what would become a vaunted lecture series. Named for former president Townsend, the Townsend Memorial Lecture Series was intended to establish the campus as a regional cultural center and expose students to prominent national and international leaders. This guestbook includes signatures of the speakers.

Eleanor Roosevelt, who became an important activist after leaving the White House, was one of the first speakers in the Townsend Memorial Lecture Series. In April 1958, she spoke at the end of the year's series, which included Sir Clement Atlee and Ogden Nash.

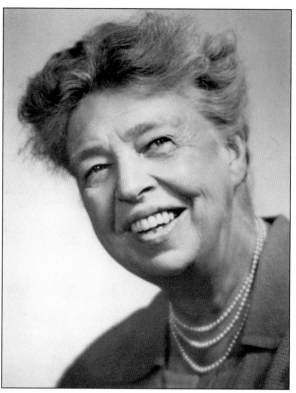

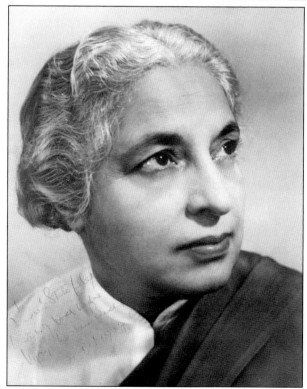

In addition to Eleanor Roosevelt, James Baldwin, Ralph Nader, George McGovern, and Kurt Vonnegut, the Townsend Lecture Series brought many more notable individuals to the Union campus. Pictured here in October 1959 is Vijaya Lakshmi Pandit, the sister of India's prime minister Jawaharlal Nehru and the aunt of future prime minister Indira Nehru Gandhi. She also served as the first woman president of the United Nations General Assembly in 1953.

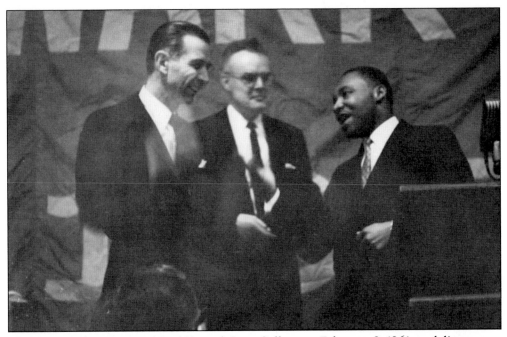

Dr. Martin Luther King Jr. visited Newark State College on February 9, 1961, to deliver a very well-received speech on the need for community action against segregation. The speech, entitled "The Future of Integration," was delivered in D'Angola Gymnasium. A commemorative plaque today marks the location. Pictured with King are President Wilkins (left) and history professor Donald Raichle.

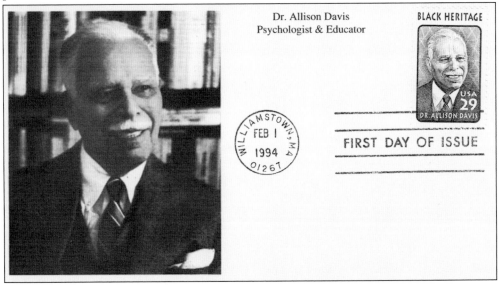

Dr. Allison Davis of the University of Chicago, one of the foremost sociologists of that time, received an appointment by President Wilkins to teach at Newark State as a distinguished professor for the 1961–1962 academic year. Davis is still considered the first major scholar to explore the impact of segregation and caste on African American children. He also led the rising public challenges to the built-in biases of standardized testing at that time. In 1994, the United States honored him with a 29¢ postage stamp, pictured here.

The visit of the popular folk group the Highwaymen in 1962 exemplified the popularity of folk music and protest songs during the 1960s. Coming out of Wesleyan University, they performed their 1961 number-one hit "Michael," an adaptation of the African American spiritual "Michael Row Your Boat Ashore."

Alan Lomax is widely viewed today as one of the greatest music folklorists of the 20th century. He was an important figure in the 1960s folk revival. In 1986, he received a National Medal of the Arts from Pres. Ronald Reagan, and in 2003, he received a posthumous Grammy for lifetime achievement in music. Lomax is shown here speaking to students in the Faculty Dining Room after a 1964 Townsend Lecture speech entitled "The Saga of American Folk Songs," given during a visit to Newark State College.

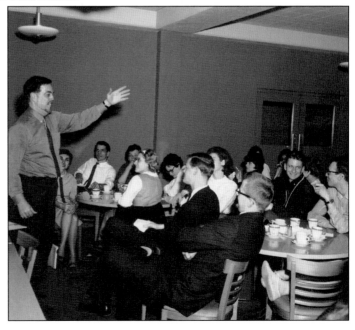

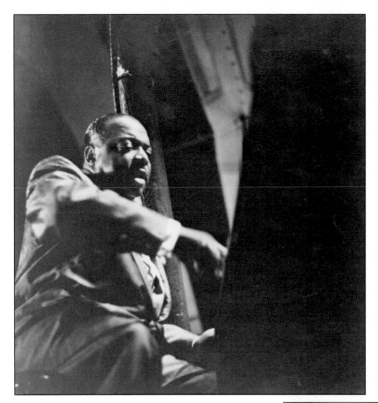

Count Basie is pictured performing at Newark State in the 1960s. Big band and jazz superstar Basie, a New Jersey native, was called by many "the Kid from Red Bank."

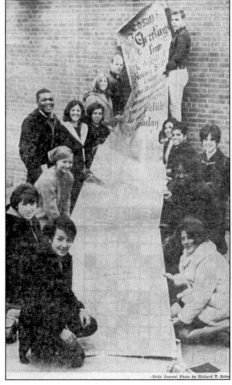

Newark State students continued their long tradition of supporting soldiers abroad. In December 1966, this enormous Christmas card was created by a largely female group of Newark State College dormitory students and sent to Gen. William Westmoreland, the American commander in Vietnam. It measured 30 feet in length and was three feet wide.

Shown here is the letter from General Westmoreland warmly thanking the Newark State students for sending the card pictured on the previous page.

News FROM ECOM

INFORMATION OFFICE
Phone: 535-1911

UNITED STATES ARMY • ELECTRONICS COMMAND

Release Date: IMMEDIATE, December 9, 1966 #91266887

 FORT MONMOUTH, N.J. -- The students of Newark State College, Union, N.J., have started what may be the world's largest Christmas Card on its way to American servicemen in Vietnam.

 A 75-foot long scroll of paper three feet wide, bearing the names of more than 2,000 Newark State students, faculty and staff members and topped by an eight-foot "Season's Greetings" was accepted on behalf of the Army today by Maj. Gen. W.B. Latta, commanding the Army Electronics Command and Fort Monmouth.

 The Paul Bunyan size holiday greeting was presented to Gen. Latta in a brief ceremony in front of ECOM headquarters by a Newark State delegation consisting of Dean ———— Herbert Samenfeld; Joseph Burns, director of residence, and Ronald Bilcik, Hightstown, N.J., chairman of the student social committee of the men's dormitory.

 The message topping the signatures reads:

 "Season's greetings from the students of Newark State College. Our thoughts and prayers go with you as you prepare for your Yuletide Holiday."

 It all started when members of the social committee of Dougall Hall, the men's dormitory, were casting about for something more meaningful to do than decorate the dormitory for the holidays.

(More)

NEWARK STATERS
BACK THE BOYS
IN VIETNAM

Paid for by Student Council Newark State College

As reflected by this popular bumper sticker, most Newark Staters initially supported the war in Vietnam; opposition grew as the war dragged on. In this sense, college students reflected the gradually shifting mood of the nation. In 1972, antiwar and local antiestablishment demonstrations brought activist Jerry Rubin to Newark State College with his stated vow to "shut down the college for the rest of the year." Cooler heads prevailed to prevent this. President Weiss and his administration, including presidential aide Patrick Ippolitto, eventually defused the situation.

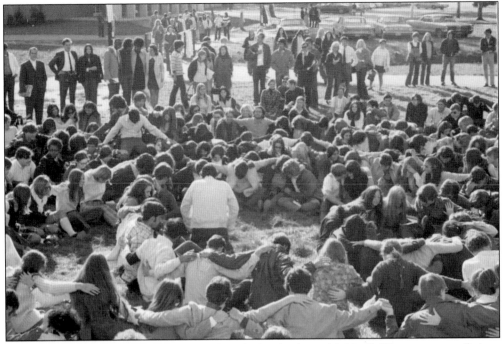

The decision by Pres. Richard Nixon to bomb Cambodia to hit North Vietnamese trails into South Vietnam sparked strong reactions on college campuses. Shown here is a student demonstration in 1970, likely in response to the National Guard shootings of student demonstrators at Kent State.

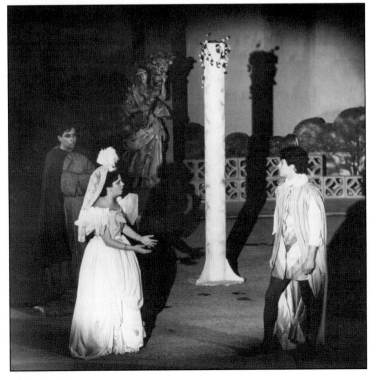

Even in the tumultuous 1960s and 1970s, Newark State students remained attracted to the classics. Here students act in a production of *Much Ado About Nothing* in 1964. Prof. Zella J. Fry directed these award-winning student plays well into the 1970s. The performances highlight the university's long commitment to the visual and performing arts, dating back to the school's pioneering efforts in training teachers in these fields in the early 20th century.

Paul Baumgartner was a well-known Swiss classical pianist. He became best known for his association with cellist Pablo Casals. This photograph shows the audience going onstage after his performance in Wilkins Theatre in the early 1970s. Wilkins Theatre remains the largest auditorium on the Union campus.

This is a good view of how the Nancy Thompson Library looked to students in 1968, before subsequent expansions and renovations. The library's transformation over the past 60 years reflects the larger changes in student habits. Increasingly, computer terminals to access journal articles and e-books have replaced traditional volumes. The library, now with a Starbucks, remains a central location for students.

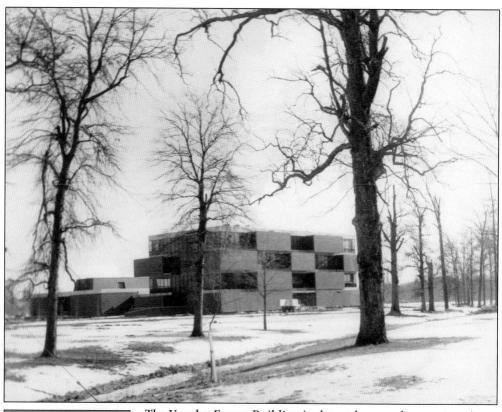

The Vaughn-Eames Building is shown here under construction in the 1970–1971 academic year. During construction, the skeleton of a mastodon was unearthed by builders. Sadly, the fossilized remains were carted away by the builder before the administration could intervene to prevent it.

The college seal symbolized Newark State's past, present, and future. The torch of learning and the open book refer to the college's educational function. The open book also appears in the seal of the Newark Board of Education, which founded the college as Newark Normal School in 1855. *Semper Discens* means "Always Learning" and is a Latinization of "Never Cease to Learn," the latter half of the college motto. The oak leaves and the Kean Library tower refer to the present campus. The silhouette of New Jersey represents the college's service to the state.

Six

FROM KEAN COLLEGE TO KEAN UNIVERSITY

The Nathan Weiss presidency lasted through the 1970s and most of the 1980s, until his retirement in 1989. His 20-year presidency was marked by a continuous expansion of new college programs, increases in faculty hiring that reached over 400 by 1985, successful campus-wide planning, and a clearly defined campus mission. However, serious issues arose over faculty hirings, reappointments, and promotions. One of the most divisive issues took place in December 1977, when two early childhood professors were not reappointed. The Faculty Senate, Kean American Federation of Teachers, and many others criticized the decision, which was later upheld by the board of trustees.

The 1970s and 1980s also revealed the president's penchant for innovation, with the creation of the Kean Instruction Team and the Center for Professional Development. Both were innovative, successful attempts to improve the quality of classroom instruction. Other challenges in the 1970s and 1980s included a one-and-a-half-day faculty strike in 1974 and a near strike in April 1983. Rising state minimum admissions standards also produced another challenge to the institution. In response, Kean created an expansive Equal Educational Opportunity program and a new program called Developmental Education. Both helped maintain the institutional focus on diversity and accessibility

In 1989, Weiss retired, and Kean's new president was Elsa Gomez, the first female Hispanic president of a four-year college in the United States. She continued a focus on student and faculty diversity but discontinued promising advancements in campus computerization and student assessment. She left the college in 1995 and was replaced by Henry "Hank" Ross, who was named interim president. Ronald Applbaum, the president of Westfield State College in Massachusetts, became the permanent president in 1997. He promptly began moving the college to becoming a university, an initiative previously initiated by Ross. Both succeeded, in that Kean College became Kean University in 1997.

The years from 1973 to 1997 were also characterized by concerts by famous musicians, including Bruce Springsteen and Jerry Garcia of the Grateful Dead. The Townsend Lecture Series continued to bring the nation's leaders and intellectuals to the campus.

It was a special time of heightened energy, school spirit, curricular innovation, and campus expansion. With an outstanding faculty and quality programs, the future continued to shine brightly for Kean University.

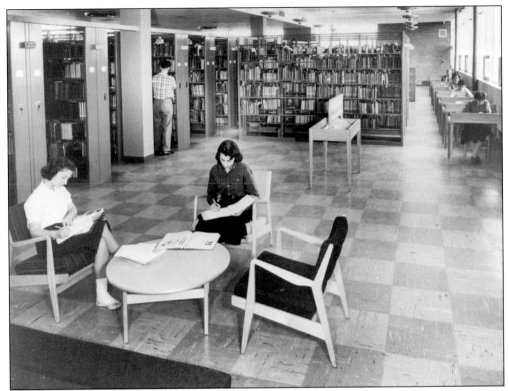

Student enrollment grew steadily in the 1970s and 1980s, more than doubling between 1973 and 1990. The student body became increasingly diverse during this time, a trend that has continued to the present, making Kean one of the five most diverse colleges in the nation.

This 1970 view of a large Newark State College sign would soon become a faint memory when, in 1973, the name was changed to Kean College. The combination of a new name and a new president greatly energized the campus community.

This is the list of suggestions for the renaming of the college developed in 1972 by the President's Committee on Name Change. The committee came up with a large list, but ultimately settled on two choices: Lenape College of New Jersey and Kean College of New Jersey, with the latter approved by President Weiss and the board of trustees in 1973.

LIST OF RECOMMENDATIONS SUBMITTED BY THE PRESIDENT'S COMMITTEE ON NAME CHANGE

May 1973

"Hamilton Kean College of New Jersey"

"Towers College of New Jersey"

"Robert Treat College of New Jersey"

"Oraton College of New Jersey"

"Stephen Congar College of New Jersey"

"Walt Whitman College of New Jersey"

"David Brearley College of New Jersey"

"Abraham Clark College of New Jersey"

"Seth Boyden College of New Jersey"

"Tuscan College of New Jersey"

"Lenape College of New Jersey"

"Alexander Hamilton College of New Jersey"

"Kean Brook College of New Jersey"

"Adlai Stevenson College of New Jersey"

"Green Lane College of New Jersey"

"Elizabethtown College of New Jersey"

"Woodrow Wilson College of New Jersey"

"Parkway College of New Jersey"

"Metropolitan College of New Jersey"

"Central Coast College of New Jersey"

"Elizabeth River College of New Jersey"

"Garden State College"

"William Morris College of New Jersey"

Three of Newark State's finest are shown here in their uniforms. Campus police were not yet permitted to carry guns. That would come later, in October 1975, when the board of trustees approved arming police between 4:30 p.m. and 7:30 a.m. after a dormitory invasion by outside individuals and an emotional campus-wide debate. The board later rescinded the time restriction.

Located in the Student Center, the Sloan Lounge was a popular hangout for students who wanted a comfortable, usually quiet, place to relax or have small group meetings. Because most students were commuters, spaces like this were essential for time between classes.

The redesign of Sloan Lounge in 1975 met with strong criticism from students. Many disliked the plastic furniture of "M&M red and yellow of near day-glo intensity," according to a December 1975 article in the *Independent*.

In 1976, Gus Garcia led Hispanic and African American students in forming a coalition to bring greater power to the two groups. He was instrumental in pressuring the president and board of trustees to allow a student ex-officio, non-voting representative on the board. Garcia also founded Lambda Theta Phi, the first Hispanic fraternity in the United States.

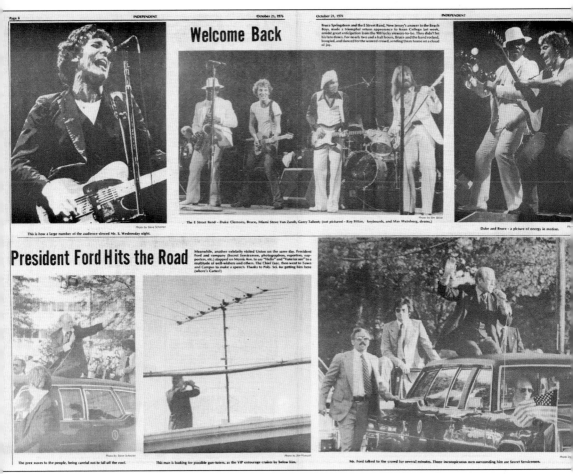

Welcome Back

Bruce Springsteen and the E Street Band, New Jersey's answer to the Beach Boys, made a triumphal return appearance to Kean College last week, amidst great anticipation from the 900 lucky viewers-to-be. They didn't let his fans down. For nearly two and a half hours, Bruce and the band rocked, boogied, and danced for the wowed crowd, sending them home on a cloud of joy.

This is how a large number of the audience viewed Mr. S. Wednesday night.

The E Street Band – Duke Clemons, Bruce, Miami Steve Van Zandt, Garry Tallent; (not pictured – Roy Bittan, keyboards, and Max Weinberg, drums.)

Duke and Bruce – a picture of energy in motion.

President Ford Hits the Road

Meanwhile, another celebrity visited Union on the same day. President Ford and company (Secret Servicemen, photographers, reporters, supporters, etc.) stopped on Morris Ave. to say "Hello" and "Vote for me" to a multitude of well-wishers and others. The Chief Exec. then went to Town and Campus to make a speech. Thanks to Poly. Sci. for getting him here (where's Carter!)

The prez waves to the people, being careful not to fall off the roof.

This man is looking for possible gun-toters, as the VIP entourage cruises by below him.

Mr. Ford talked to the crowd for several minutes. Those inconspicuous men surrounding him are Secret Servicemen.

New Jersey's rock and roll superstar Bruce Springsteen played several concerts at Kean College in the 1970s. Long before he was discovered by the rest of the country, he was a popular local performer. This newspaper article on his 1976 concert, soon after his *Born to Run* album, is accompanied by a story on another visitor to the campus, Pres. Gerald Ford.

Former president Gerald Ford is shown here accepting a Kean shirt from President Weiss during his visit to the campus in 1976. In addition to meeting with students and faculty, Ford was a guest of the Kean family at Liberty Hall.

This is an excellent image of the Newark State basketball team, still wearing the name of Newark even after the move to Union. While athletics had always been a part of the college curriculum and student life, under the leadership of physical education professor Joseph D'Angola, participation was emphasized over competition. In recent decades, however, Kean has built a strong athletic tradition, winning several national and many more conference and regional championships.

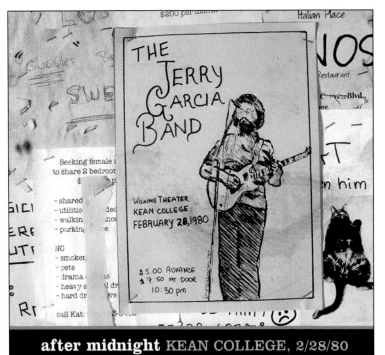

This is the cover of the Jerry Garcia Band's album *After Midnight: Kean College, 2/28/80*, which features recordings of performances at Kean in 1980. The lead singer of the Grateful Dead was another in a long line of famous performers to play on campus. This recording was released in 2004 and remains prized by collectors. (Courtesy of the estate of Jerry Garcia.)

The cover of this commencement program from 1979 was signed by two honorary degree recipients, US senator from New Jersey Clifford P. Case and popular children's book writer Roger Duvoisin. Both were warmly received by the graduates. Case supported higher education as a senator, while illustrator Duvoisin visited English professor Sid Krueger's classes on children's literature to speak with Kean students.

Fine arts professor Austin Goodwin, along with his colleague Prof. Martin C. Buchner, designed the mace and necklace used in every university commencement since 1981. The mace is carried by the most senior faculty member, while the president always wears the necklace. The mace is a medieval symbol of power, while the necklace consists of a silver medallion inscribed with the names of past presidents.

Pres. Nathan Weiss and Gov. Thomas H. Kean are shown leading the procession at a graduation ceremony in the early 1980s. At that time, commencement was held in front of Townsend Hall. Carrying the mace is Prof. Doug Tatton.

In 1983, Pres. Ronald Reagan's National Commission on Excellence in Education published its landmark report *A Nation at Risk*. The report led to major changes in the American educational system. Among the major recommendations was one to assess the quality of teaching at all levels, including colleges. Roger Sharp of ABC News is shown interviewing students, including future educational leaders such as Susan Miksza, left, to get reactions to the report. Miksza currently teaches education courses at Kean University.

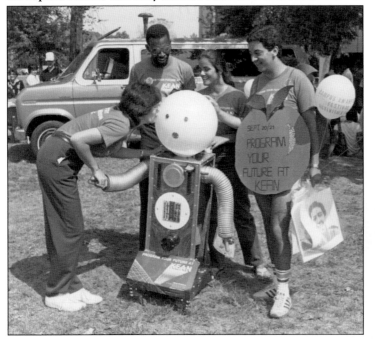

This image reflects the growing diversity of the student population in the Weiss administration. The university has received national recognition for its diverse student body and maintains a strong commitment to providing excellence in higher education for the changing population in the surrounding counties.

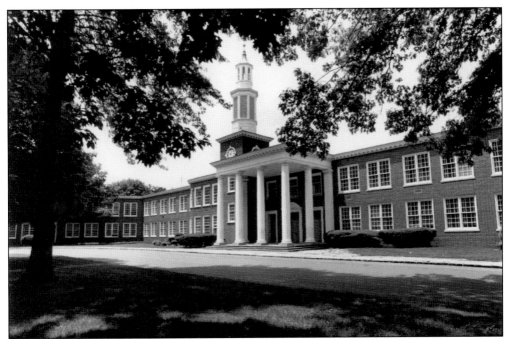

This is a striking image of the present East Campus building that houses the Nathan Weiss Graduate College. The acquisition of the building by President Weiss and its restoration by Pres. Dawood Farahi enabled the university to expand to the other side of the Elizabeth River.

The purchase of the former Pingry School property in Hillside by the Weiss administration proved to be an important one. As shown here, it brought much-needed classroom space to Kean College as enrollment expanded. Unfortunately, the mural in the background depicting the founding of Elizabethtown was covered during a major renovation in 2008.

Pictured here is Dorothy Hennings, a now-retired distinguished professor of education, an outstanding writer, and an elementary teaching expert who has written many widely used textbooks. Dorothy and her husband, George, also a faculty member, taught at Kean for a combined 63 years. The couple met while teaching at Kean. Hennings Hall was named in their honor.

A World War II Army veteran, Prof. George Hennings taught biology, astronomy, and geology courses, and developed Kean's innovative program in science education during his 27 years of service at Kean. Together he and his wife, Dorothy, taught over 15,000 Kean students.

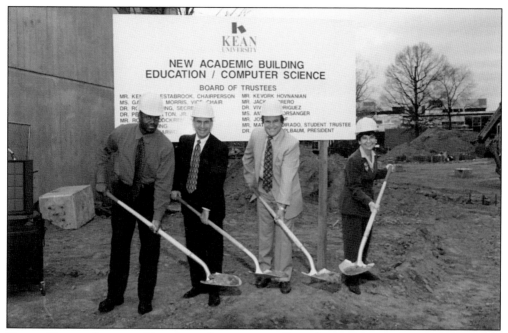

Pictured here at the ground-breaking of Hennings Hall are, from left to right, Charles Anderson, President Applbaum, Eduardo DelValle, and Ana Maria Schumann. Hennings Hall houses the College of Education. Although the mission of the university has expanded greatly over time, preparing future teachers for the state remains central to the institution.

Dr. Dawood Farahi, chairman of the public administration department, is shown here providing advice to a student in the late 1980s. Farahi went on to serve in a number of leadership positions, including chair of the University Senate. In 2003, he was named the 21st president of Kean University, leading the university in the first decades of the 21st century.

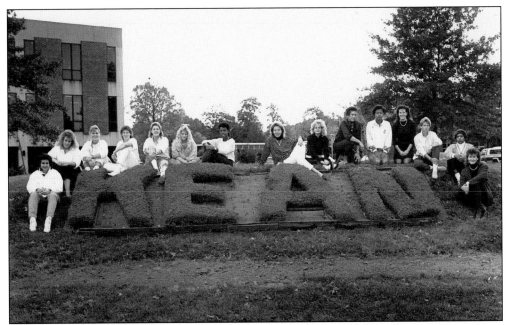

Located at the circle in front of Townsend Hall, this earthen mound caught a lot of attention. Many rumors circulated that a Volkswagen Beetle was buried beneath it. Others believed that the car was buried near the gymnasium.

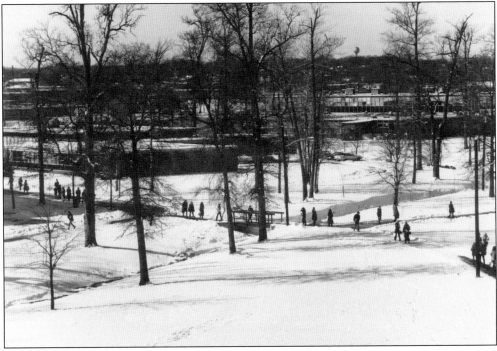

This snow-covered scene shows the Technology Building in the foreground, and Townsend and Bruce Halls in the background, as they looked in the 1980s. While many new buildings have been added to the campus since 2007, these original buildings continue to house classrooms, laboratories, and offices.

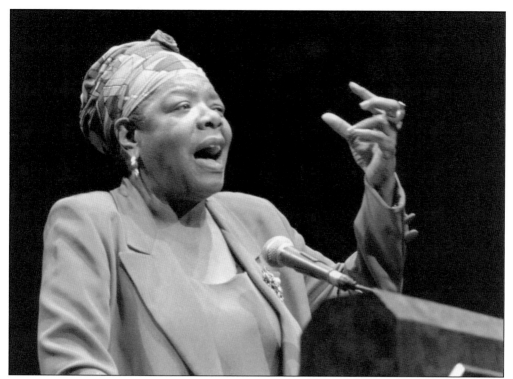

Famed poet Maya Angelou spoke several times at Kean. She received an honorary degree from Kean College in 1982, and was the 2009 graduate commencement speaker.

The library has received several renovations over the years. This is the library prior to the 2010 addition of the Human Rights Institute's wing in the space to the left of the doorway.

Pictured here is the founding board of the Kean Holocaust Resource Center with Gov. Thomas H. Kean in 1982. The governor (right center in back row) was a strong supporter of the center. He later created the statewide Holocaust Commission. Sister Rose Thering, later a Kean University board member and a faculty member at Seton Hall University, was later appointed to the state commission.

"Sister Rose," as she was known, was a dynamic leader who helped guide Kean University in the 1990s and early 2000s as a member of the board of trustees. A film of her life called *Sister Rose's Passion*, by director Oren Jacoby, was nominated for an Academy Award. She was a successful advocate for encouraging the changing of the earlier erroneous teachings of the Catholic Church regarding the role of Jews in the killing of Christ.

President Weiss wrote this memoir of his sometimes turbulent 20-year tenure as president. He experienced major challenges as the faculty unionized and the union voted to strike and students demonstrated and took over his office. His battles with state officials were frequent in his earlier years. Perhaps more than any other Newark State/Kean College president in the last century, Weiss used his considerable managerial and political skills and prescient vision to build and shape the present university.

At the Center of the Storm:

Reflections of a State College

President

by Nathan Weiss

Coach Tony Ochrimenko built the Kean men's soccer team into a perennial powerhouse in the 1980s, culminating in the first national championship in men's sports for the college in 1992. The Cougars defeated Ohio Wesleyan 3-1 in the NCAA Division III championship game, culminating a 10-game winning streak that carried it to the title.

In the late 1990s, the tradition of parading the Homecoming King and Queen around the football stadium took hold. The then-recently renovated stadium featured a press box and another box for guests and alumni. Homecoming continues to be a signature event for the campus community and its more than 60,000 alumni each fall.

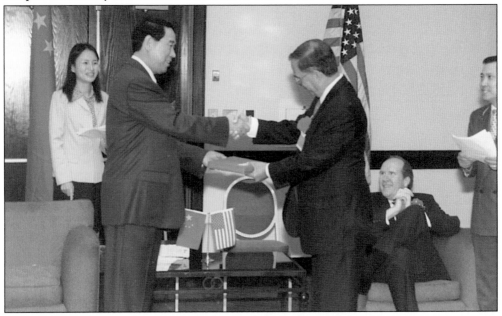

Pres. Ronald Applbaum is shown here in 1997 with a representative from the Chinese government announcing the school's first exchange agreement to begin providing graduate training for Chinese students in public administration. The relationship flourished in the years ahead, leading to a historic agreement to open a campus in Wenzhou, China.

Seven

A GLOBAL UNIVERSITY

Growing and expanding for almost 150 years, Kean College became Kean University in 1997. Given the growth of academic programs, graduate degrees, public programs, and performances, the former normal school had become a powerful regional center for culture and education. Today, Kean University offers more than 130 undergraduate and 75 graduate degrees through its eight colleges and centers. Still the largest producer of teachers in the Garden State, Kean also boasts prominent alumni in varied fields including business and finance, media and communications, fine and performing arts, and education.

Kean University has grown dramatically in the 21st century in other ways as well. Alumni returning to the campus in Union immediately note the disappearance of muddy pathways, and the appearance of new structures has given the campus a decidedly modern feel.

Under the leadership of Pres. Dawood Farahi, the campus has added classroom and research facilities including the STEM Building, the Green Lane Building, and the North Avenue Building. While many Kean University students commute to campus, new dormitories have contributed to the growth of a residential community at Kean. The growth in facilities has coincided with a growth in enrollment. In 2016, the university boasted student enrollment of almost 17,000, making it the third largest state university in New Jersey.

At the same time, the campus has expanded its geographical footprint, both in New Jersey and around the world. Kean University expanded its reach southward by partnering with Ocean County College (OCC) to allow OCC students to take Kean University courses and complete Kean University degrees on the OCC campus. The university also looks to the northwestern part of the state and its Kean University Highlands Campus, which serves as an environmental and sustainability education center.

In 2012, Kean University officially extended its footprint overseas. After many years of collaboration and planning, Kean opened a campus in Wenzhou, China. Wenzhou Kean University provides American-style education to Chinese students and offers Kean students the opportunity to study in China.

Formerly the Squires, on February 15, 1985, the campus voted and adopted the Cougar as its new mascot. The Kean Cougar can be found at sporting events, campus activities like Open House and Homecoming, and other campus happenings. More recently, Kean students, staff, faculty, and alumni have adopted two cougars, Scout and Sage. They are housed at Essex County's Turtle Back Zoo in West Orange, New Jersey.

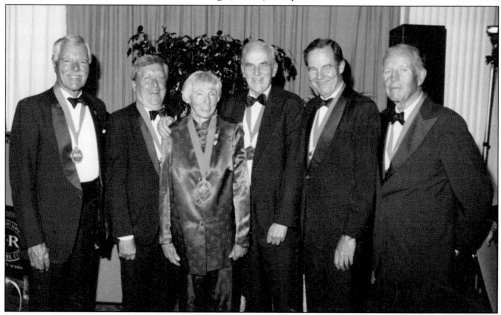

In 1997, the Kean Foundation held the first gala in honor of the Kean family. Pictured here are John Kean, Stewart B. Kean, Mary Alice Kean, Hamilton Fish Kean, former governor Thomas Kean, and Robert Kean Sr. wearing medallions gifted to them by the university. This was the start of a close relationship that continues to this day.

As part of the campus's recognition of World AIDS Day on December 1, 1992, a series of events were held throughout the week. Among the highlights was the display of the AIDS quilt, which memorializes the names of those who died from AIDS to ensure that they are not forgotten. Here, Jette Englund (left) and Millie Gonzales view part of the quilt.

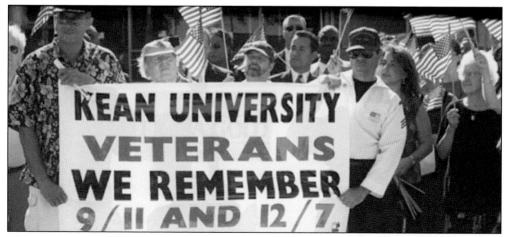

The terror attacks of September 11, 2001, shocked the university as they did the rest of the country. Smoke rising from the fallen towers in Manhattan could be seen from campus. Student leaders and interim president Frank Esposito dedicated a special memorial to the victims on the university's Day of Remembrance one year later.

Completed in 2002, the former library of Sen. Hamilton Fish Kean was renamed Kean Hall. The renovations blend the French Renaissance style of the original structure with the modern. The building is home to the administrative offices for the president and vice president of academic affairs, as well as the Office of Admissions, among others. The stunning building serves as a connection between the school's history and its future.

The Estabrook Garden was created by the Farahi administration in honor of the late Kenneth Estabrook, a member of the board of trustees who died in 2003, and Anne Evans Estabrook, his wife, both generous benefactors of the university.

102

The opening of the Union train station in 2003 greatly expanded the ease with which faculty, staff, and students can get to campus. The school's location, with a direct rail link to Manhattan, which is visible from many campus buildings, provides unparalleled academic, cultural, and business opportunities for the Kean community.

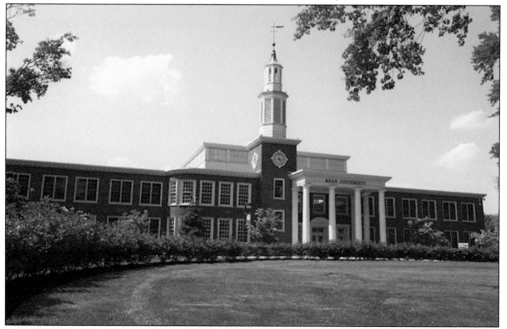

The former Pingry School building was acquired by university president Nathan Weiss in the 1980s to accommodate the needs of the rapidly growing student body. The building was renovated to serve as classrooms for programs in occupational therapy, educational leadership, psychology, and other fields.

In 2004, Kean University launched the New Jersey Center for Science, Technology, and Mathematics. This program continues Kean's longstanding mission of training teachers, in this case for key fields in the 21st century. The program is housed in the STEM Building, a state-of-the-art research facility that includes labs, classrooms, and conference facilities.

The Maxine and Jack Lane Center for Academic Success is a cornerstone of Kean's commitment to opportunity. The structure is home to many of the university's student support offices, all of which serve the purpose of ensuring that students will have the tools necessary to receive a world-class education. Upon completion in 2005, it became the first higher education facility in New Jersey to receive LEED (Leadership in Energy and Environmental Design) certification by the US Green Building Council.

In 2005, John Kean was awarded an honorary doctor of laws degree from the university. He was recognized for his many contributions to the university as well as his tremendous success in running the Kean family businesses, most notably the Elizabethtown Gas Company. He is pictured here on the left with Dr. Vinton Thompson, the university provost.

In 2006, Kean University partnered with Ocean County College to create Kean-Ocean to provide higher education in Ocean County. Kean-Ocean enables students to pursue a bachelor's degree without leaving Ocean County by taking Kean courses on the OCC campus. The new Gateway Building opened in 2013.

In 2006, Kean president Dawood Farahi (right) entered into an agreement with Xi Jinping (left), party secretary of Zhejiang Province and now president of the People's Republic of China, for Kean to build and operate a campus in Wenzhou, Zhejiang Province. This agreement was the culmination of many years of exchanges, negotiations, and a strong relationship between Kean officials and those in Zhejiang. Wenzhou Kean University opened to students in 2012.

In 2007, Kean won the NCAA Division III World Series over Emory University with a thrilling 5-4 win in 10 innings. That year marked the team's first College World Series appearance, and the team set a school record with 43 victories. The team continued its tremendous run of success under coach Neil Ioviero with six more College World Series appearances over the next nine years.

Kean's college deans assembled for this photograph in the lobby of Townsend Hall. From left to right are Charles Anderson, Frank J. Esposito, Betty Barber, Ana Maria Schumann, and Edward Weil. Their leadership helped propel Kean's graduates to successful careers in a variety of fields.

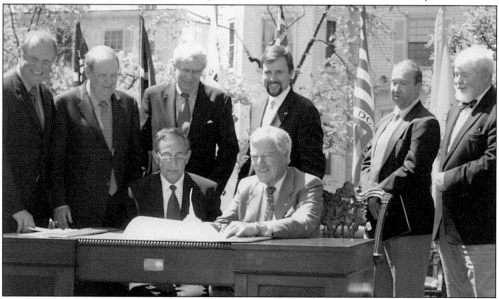

On May 9, 2007, Kean University acquired the Liberty Hall Mansion, archives, and land for $5.1 million. About 200 people attended the ceremony, including many members of the Kean family, university faculty, staff, and students, and local politicians. The Liberty Hall Museum campus and archives provide Kean University with a unique resource for research and education.

Liberty Hall Museum's vast collection includes historic fire engines and memorabilia. Since becoming a museum, Liberty Hall has developed extensive educational programming, offering hands-on learning experiences for area schoolchildren, Girl and Boy Scouts, and summer campers. In this photograph, children learn about both fire safety and the history of firefighting.

Liberty Hall Museum explores new ways to bring history to the public by mounting rigorous exhibitions based on the museum's collections around themes such as clothing, travel, and toys, and hosting historically themed social events. In 2013, Liberty Hall launched an exhibit titled "Ring for Service: The Role of Servants in a Country House" and raised the same notions in *Downton Abbey* luncheons and dinners.

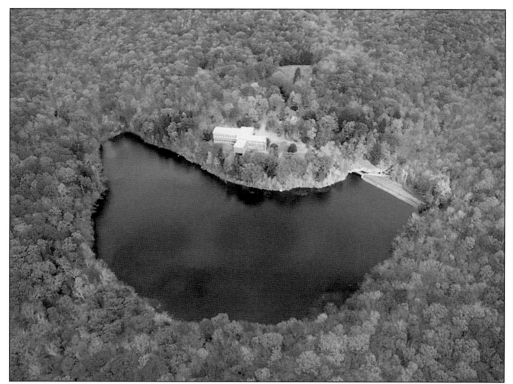

In 2012, Kean acquired 41 acres and a former lodge in the New Jersey Highlands as the university continued to expand, this time into Sussex County. The Highlands region provides much of the state's drinking water. The former retreat house for the Paulist Fathers now serves as a unique location for studying biology, ecology, and the emerging field of sustainability studies.

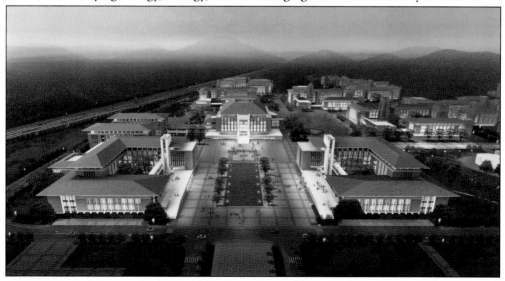

In 2012, Kean became the first public institution of higher education to open a satellite campus in China. The construction of Wenzhou Kean University was the culmination of a strong relationship between the university and leaders from Zhejiang Province, many of whom earned graduate degrees in public administration from Kean.

From an initial student body of 150 in 2012, Wenzhou Kean grew to more than 1,500 students in the fall of 2016. The university offers degree programs in business, computer science, design, and English. All classes are conducted in English. In May 2016, the first commencement for 186 graduates was held at Wenzhou Kean University.

On April 29, 2013, New Jersey governor Chris Christie joined five of his predecessors in a celebration at Liberty Hall, the home of New Jersey's first elected governor, William Livingston. More than 300 guests celebrated at the historic home, which became part of Kean University in 2007. From left to right are James Florio, Thomas H. Kean, Christie, Donald DiFrancesco, James McGreevey, and Richard Codey.

Kean's faculty has distinguished itself in many areas of scholarship. Science professor Xiaobo Yu's accomplishments are an excellent example of the cutting-edge research that characterizes the Kean faculty. In 2014, *Nature* magazine featured Yu on its cover for having unearthed the remains of a previously unknown 419-million-year-old fossil fish in China.

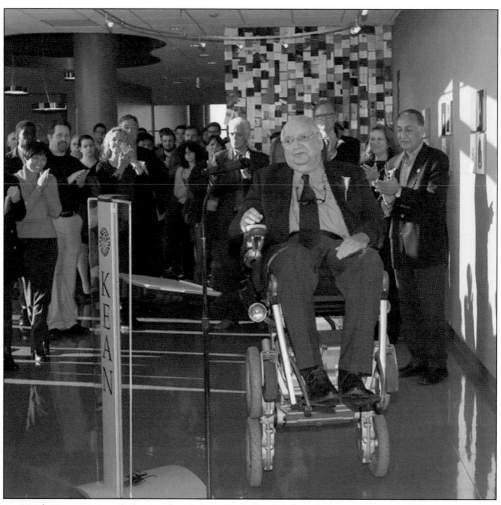

In 2014, Kean opened the Michael Graves College of Architecture to its initial class of 25 students. Named for the renowned architect, the college is comprised of the Robert Busch School of Design and the School of Public Architecture and resides in the Green Lane Building. In 2016, Kean acquired the Warehouse, the home of Michael Graves in Princeton. Graves also designed the College of Architecture building at Wenzhou Kean University.

Eight

THE LIVINGSTON AND KEAN FAMILIES

Green Lane Farm and adjacent portions of the Kean estate became integral to the college's history in 1954, when Robert Winthrop Kean sold 120 acres of family land to the State of New Jersey. Here would be built the new Union campus of Newark State Teachers College.

But the estate has a much older connection to the history of New Jersey. Located in what was then Elizabethtown, the land was purchased in 1760 by William Livingston, who intended to retire there from a career as a lawyer in New York City. Livingston spent the next decade developing what would eventually become not only an important farm but also an important epicenter in the political history of New Jersey and the young United States.

Livingston became New Jersey's first elected governor in 1776, a position he held until his death in 1790. He welcomed many American leaders to Liberty Hall, from John Jay (who married one of his daughters) and Alexander Hamilton to Martha and George Washington, who visited in 1789.

After Livingston's death, the property was sold, but it was returned to the family in 1811 when Peter Philip James Kean purchased the property in trust for his mother, Susan Livingston Kean Niemcewicz (niece of William Livingston). Susan renamed the home Ursino in honor of her second husband, Julian Ursyn Niemcewicz. Over time, the home expanded to accommodate generations of the Kean family. Often, these additions reflected the prevailing architectural trends of the time. William Livingston's 14-room country home is now a 50-room Victorian Italianate–style villa. On the other side of Morris Avenue, Hamilton Fish Kean built Green Lane Farm, which operated commercially until the land was purchased for Newark State.

The rest of the estate remained in the Kean family until 1997, when John Kean donated Liberty Hall to the Liberty Hall Foundation and the home became a museum. In 2007, Kean University acquired Liberty Hall to serve as a museum and classroom and to preserve this important history for Kean and New Jersey. This agreement joined the remainder of the Kean estate, along with important archival materials now housed in the Ice House, with the university.

William Livingston (1723–1790), member of the powerful Hudson River Valley Livingston family, built a successful career as an attorney in New York. He decided to retire to a quiet country life in New Jersey and in the early 1770s built a 14-room Georgian-style mansion, named Liberty Hall, in Elizabethtown. During the American Revolution, Livingston commanded the New Jersey militia, and served as governor from 1776 until his death in 1790. This portrait was loaned to Chris Christie during his term as New Jersey governor. (Courtesy of the John Kean Collection at Liberty Hall Museum.)

An outspoken patriot, military commander, and political leader, Livingston was frequently pursued by British and Hessian soldiers during the Revolution. Family legend holds that one night soldiers invaded Liberty Hall in search of the governor and pertinent papers. Livingston's daughter Susan hid her father's papers from the enemy under the skirt of her dress, claiming they were her own private letters. The soldiers left, but not before hacking the bannister of the stairwell with their swords. After the war, the estate was brought back to its former glory, but the hack marks remain to this day. (Courtesy of the John Kean Collection at Liberty Hall Museum.)

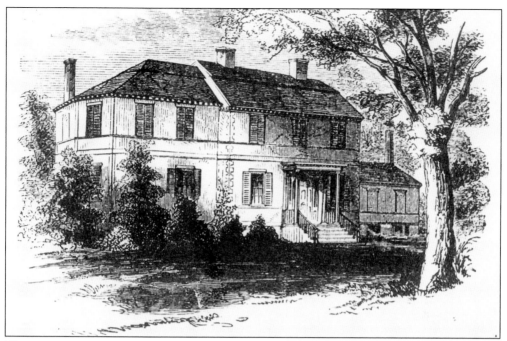

There are no surviving images of the original house as built by Livingston. The estate was sold after his death, but in 1811, it was purchased in trust by Peter Philip James Kean for his mother, Susan Livingston Kean Niemcewicz, William Livingston's niece. The house remained in the Kean family until 1997, when John Kean Sr. donated Liberty Hall to the Liberty Hall Foundation. In 2007, Kean University merged with Liberty Hall Museum. (Courtesy of the John Kean Collection at Liberty Hall Museum.)

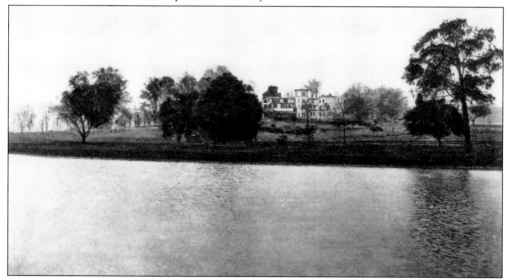

Around 1874, to meet the needs of the people of Elizabeth, the Elizabethtown Water Company purchased the Ursino Lake property, located along the Elizabeth River behind Liberty Hall, to create the Irvington reservoir. The former reservoir is a mere stream now, with a one-lane bridge that connects the Liberty Hall campus and East Campus. Note that the Pingry School (now East Campus) was yet to be built. (Courtesy of the John Kean Collection at Liberty Hall Museum.)

This 1889 photograph shows three generations of the Kean family. Col. John Kean (1814–1895) is seated on the front porch of his mansion. Standing at left is his daughter-in-law Katharine Taylor Winthrop Kean holding John Kean. Next to her is daughter Christine Griffin Kean Roosevelt holding Lucy Margaret Roosevelt. Christine married William Emlen Roosevelt, cousin to Pres. Theodore Roosevelt. Their son George Emlen Roosevelt and daughter Christine Roosevelt are on either side of the colonel. Grandson George Barclay Rives is leaning on the post. (Courtesy of the John Kean Collection at Liberty Hall Museum.)

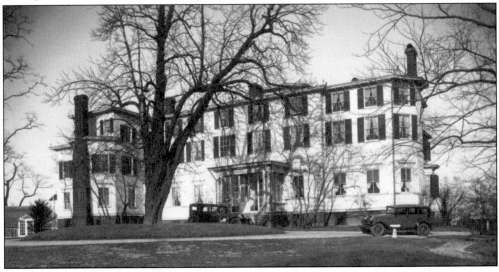

Liberty Hall served as the chief residence and summer escape from New York City for many generations of the Kean family. As the family grew, the mansion was enlarged in successive additions. This 1930s view of the house shows the horse chestnut tree that still stands in front of the house. One of the oldest documented trees in New Jersey, it was grown from nuts acquired by William Livingston from a London nursery. According to family legend, it was planted by Livingston's daughter Susan in the early 1770s. (Courtesy of the John Kean Collection at Liberty Hall Museum.)

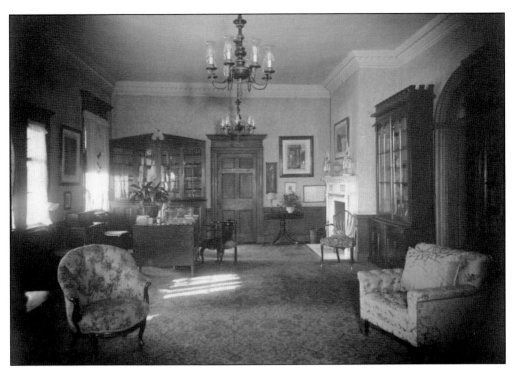

This 1930s view shows the great hall inside the mansion. The double front doors are on the left, with the door to the dining room at center. The wall-to-wall carpet and wallpaper pictured here were removed by Mary Alice Barney Kean in the 1950s. They were replaced with large wood-plank floors and gray paint. When Mary Alice hosted parties, she requested that women refrain from wearing high-heeled shoes that could damage the floors. (Courtesy of the John Kean Collection at Liberty Hall Museum.)

The parlor was traditionally the women's space in the house. The Livingston and Kean women were powerful in their own right, running the estate, joining prominent families together through marriage, and serving as hostesses at Liberty Hall and in Washington, DC, to a constant stream of political dignitaries. This room also bears witness to the Kean penchant for technology: the light fixtures are an unusual combination of gas and electric. An elevator was installed in 1925, when electricity was added. (Courtesy of the John Kean Collection at Liberty Hall Museum.)

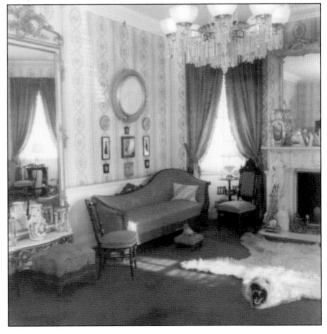

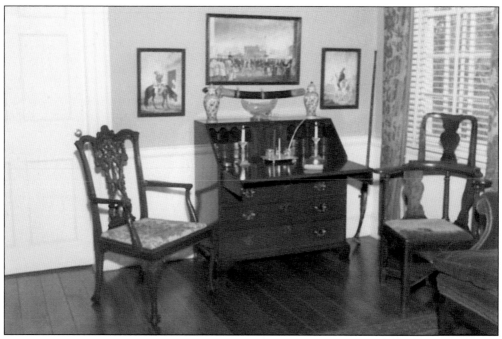

This view of the great hall includes the sword of Count Julian Ursyn Niemcewicz, above the desk. According to family lore, the sword originally belonged to John Sobieski, 18th-century king of Poland, who used it at the Siege of Vienna. A Polish nobleman and supporter of Polish constitutionalism, Niemcewicz came to the United States, where he married Susan Livingston Kean, niece of William Livingston and widow of John Kean, in 1800. Susan renamed the mansion Ursino in his honor. In 1807, Niemcewicz returned to Poland, and remained a central figure in Polish politics until exiled to Britain. Though he and Susan Livingston Kean remained married, he never returned to the United States. (Courtesy of the John Kean Collection at Liberty Hall Museum.)

This view of the garden is from the steps of the glass porch. Extensive gardens have been part of Liberty Hall since its construction by William Livingston in the 18th century. He planted a large apple orchard before the house was completed and imported fashionable plums and pears from English nurseries. This May 1965 photograph shows a formal, symmetrical garden installed by Mary Alice Barney Kean to recall an earlier era in the garden's history. (Courtesy of the John Kean Collection at Liberty Hall Museum.)

THE ROSE GARDEN, URSINO, ELIZABETH, NEW JERSEY

William Livingston, an enthusiastic gardener, began the gardens of Liberty Hall before he constructed the house. He had a yellow early blooming rose named after him that still grows to the far left of this view. George Belaise, Lord Bolingbroke, who purchased the estate from Henry Brockholst Livingston in 1798, introduced the English landscape-style garden to the estate and expanded its ornamental tree plantations. One can still walk along the serpentine path he created. (Courtesy of the John Kean Collection at Liberty Hall Museum.)

The Liberty Hall estate was a fully functioning farm through the middle of the 20th century. Barns provided shelter for dairy cows, chickens, ducks, horses, corn, and wagons. Scraps from the house were disposed of biweekly in a pigpen on the other side of Morris Avenue. The fields shown here grew hay and corn for silage. During World War II, a shortage of farm laborers led the Kean children, May, John, and Stewart, to help with the hay harvest. (Courtesy of the John Kean Collection at Liberty Hall Museum.)

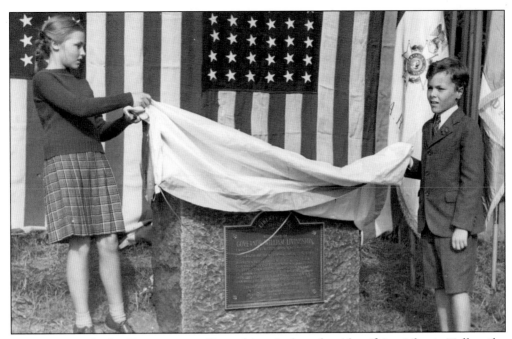

Young May and John Kean are unveiling a historical marker identifying Liberty Hall as the residence of William Livingston on September 18, 1937. The marker was placed on Morris Avenue near the former entrance to the house. John Kean was instrumental in achieving his mother's dream of turning Liberty Hall into a museum and is still actively involved in fulfilling its mission. (Courtesy of the John Kean Collection at Liberty Hall Museum.)

The Kean family are seated under the horse chestnut tree in front of the house. From left to right are (first row) Mary Alice, John, and Stewart; (second row) Mary Alice Barney Kean and Capt. John Kean. They were the last family in residence. This photograph was taken shortly before the death of Capt. John Kean. Mary Alice loved Liberty Hall, and it was her vision to turn it into a museum. She received an honorary doctorate of humane letters from Kean College in 1974. The last family member to reside in the mansion, Mary Alice died in 1995. (Courtesy of the John Kean Collection at Liberty Hall Museum.)

On November 28, 1972, Mary Alice Barney Kean and her son John Kean received a plaque from the National Park Service recognizing the William Livingston House as a National Historic Landmark. In addition to directing the restoration of Liberty Hall, Mary Alice was very involved with historic preservation in New Jersey and New York. (Courtesy of the John Kean Collection at Liberty Hall Museum.)

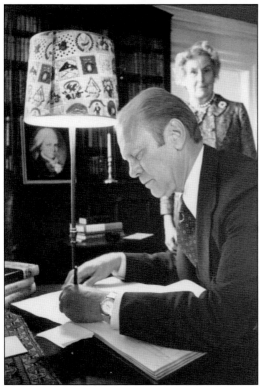

In 1976, Pres. Gerald Ford signed the guestbook at Liberty Hall beneath a portrait of John Kean. After this visit, he attended a rally at Kean College. Eight US presidents have visited the home: George Washington, William Henry Harrison, Ulysses S. Grant, Teddy Roosevelt, William Howard Taft, Herbert Hoover, Gerald R. Ford, and George H.W. Bush, as vice president. (Courtesy of the John Kean Collection at Liberty Hall Museum.)

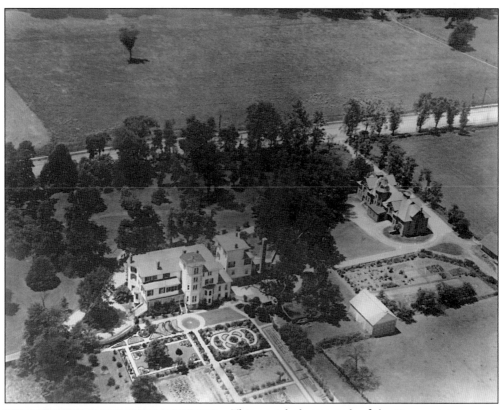

This aerial photograph of the Kean estate was taken in the 1950s, just prior to the arrival of the college from Newark. This image shows a rare view of the mansion, gardens, and farm. Note how Morris Avenue and the land beyond are bare. (Courtesy of the John Kean Collection at Liberty Hall Museum.)

Hamilton Fish Kean (1862–1941) was the son of Col. John Kean and Lucinetta Halsted Kean. In 1888, he married Katharine Taylor Winthrop, and they had two sons, John Kean and Robert Winthrop Kean. His career included serving as director of the Elizabethtown Gas Company, the Elizabethtown Water Company, and the National State Bank of Elizabeth. He represented New Jersey as a US senator from 1929 to 1935. Here, he stands next to the corner tower, whose doorway led up a spiral staircase to his private apartment. Perched above the ivy is the carved stone head of the architect, Julius F. Gayler. (Courtesy of the John Kean Collection at Liberty Hall Museum.)

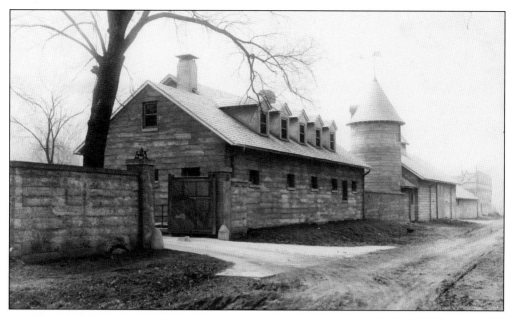

Hamilton Fish Kean built and developed Green Lane Farm after he inherited the land from his father. In this view, the farm buildings are under construction. The complex of farm buildings included a retail store facing Morris Avenue, where produce and milk from the farm were sold to the public. A greenhouse was on the opposite side, and family legend says that top-secret DDT experiments took place there. This entranceway is no longer present, but the roadway in the picture is still used today. (Courtesy of the John Kean Collection at Liberty Hall Museum.)

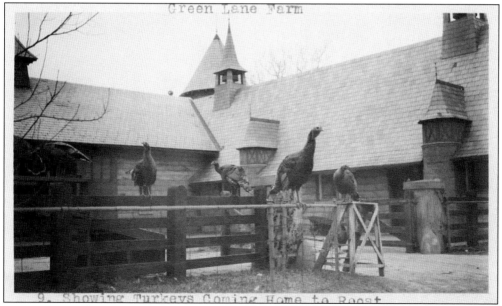

Here turkeys come in to roost. The Green Lane Farm was known for its prize-winning livestock, and cattle, pigs, and poultry roamed the farm. After the death of Hamilton Fish Kean, the farm was rented and continued to function agriculturally until the land was purchased for the college in 1953. (Courtesy of the John Kean Collection at Liberty Hall Museum.)

An unidentified cow is pictured at Green Lane Farm. Several of the Green Lane Farm Guernsey cows set records for the most milk and butterfat produced by a single cow in a year. A 1928 article from the *New York Times* states that Lily produced an astounding 15,364 gallons of milk, 741.8 pounds of which were butterfat. The average milk production for a cow at that time, according to the New Jersey Guernsey Breeders' Association, was 4,000 gallons and 147 pounds of butter fat. (Courtesy of the John Kean Collection at Liberty Hall Museum.)

It took many years to complete the main structure of Green Lane Farm, a building called the Library. Construction began in 1915 but was delayed by World War I. A blacksmith shop was established on the property for English craftsmen to forge all the garden gates, railings, and other wrought-iron work on the premises. All the woodcarving was also done on site. In the 1920s, there were two woodcarvers and four cabinet makers and carpenters working. This picture, dated June 7, 1920, is a rare glimpse of the Library still under construction. (Courtesy of the John Kean Collection at Liberty Hall Museum.)

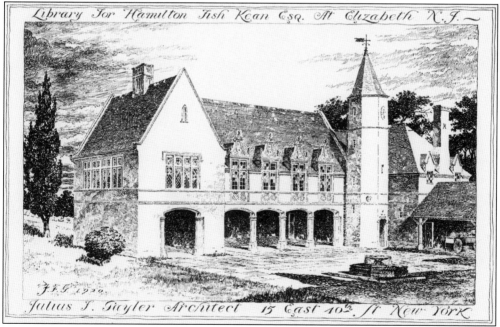

Hamilton Fish Kean wanted the Library to reflect a chateau he had seen and admired in France. The beautiful structural and decorative features of the French Renaissance style give the impression of a very old structure, despite it being finished in the early 1920s. The second floor included a library, two bedrooms, and a bathroom. Stewart Kean recalled his grandfather taking him on walking tours of the farm every Saturday, after which they would roast chestnuts and play in the fountain in the Library. The Library was also the place where Hamilton Fish Kean held political meetings.

125

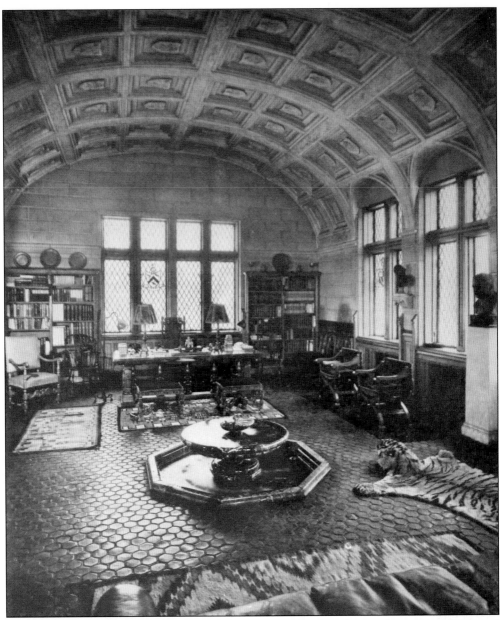

The library contained Hamilton Fish Kean's desk and books. The windows were decorated with the Kean and Winthrop family crests. The room was designed so that the fireplace stack could be pushed up into the ceiling and covered when not in use, while a fountain would take its place. The wood paneling came from the famous Nottingham Forest in England. Today Kean University uses this space as a meeting room.

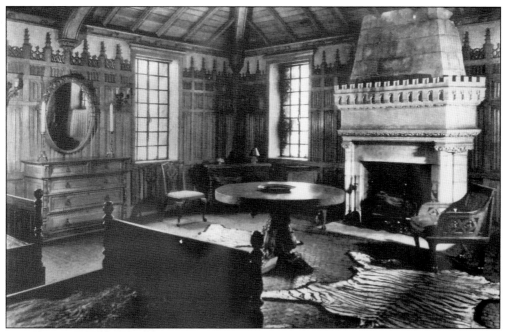

The bedroom of Hamilton Fish Kean in Green Lane Farm included a vaulted ceiling, terracotta tile floors, and extensive wooden paneling. The doorway on the left led to the bathroom, which was accented with irregularly shaped chips of turquoise. The linen-fold wall paneling includes several secret compartments. The mantle is inscribed: "Listen and say nothing, work and be silent, my joy is in my heart."

This is another image of the bedroom from a different point of view. The room was furnished with two beds and one of several animal-skin rugs that decorated the Library. Today, this space serves as the office for the president of Kean University.